Around
Stockton
& Norton

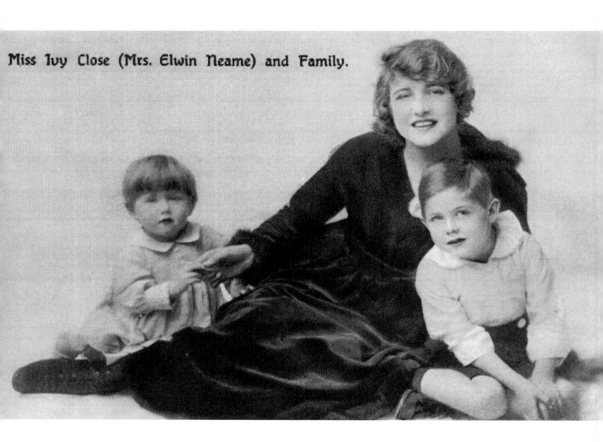

Miss Ivy Close (Mrs. Elwin Neame) and Family.

Ivy Close, who was born in Stockton on 15 July 1890, became the town's own Hollywood star. After winning the *Daily Mirror*'s Most Beautiful Woman contest in 1908, Ivy married Elwin Neame in 1912 and went on to become a silent movie star during the era of Charlie Chaplin. She made her first film in *The Lure of London* in 1914. In 1916, she sailed to New York and there made forty-film before retiring in 1922 to look after her children. After her husbands demise and a failed attempt to ressurect her career in America, Ivy returned to the UK. Sadly, she died alone in a nursing home on 4 December 1968.

BRITAIN IN OLD PHOTOGRAPHS

AROUND STOCKTON & NORTON

PAUL MENZIES

I would like to dedicate this book
to Jackie, Drs Lara and James Pickett, and Martin Menzies.

First published 2011

The History Press
The Mill, Brimscombe Port
Stroud, Gloucestershire, GL5 2QG
www.thehistorypress.co.uk

British Library Cataloguing in Publication Data.
A catalogue record for this book is available from the British
Library.

ISBN 978 0 7524 5731 4

Typesetting and origination by The History Press
Printed in Great Britain

CONTENTS

ABOUT THE AUTHOR

Paul Menzies has written and broadcasted extensively on the Teesside region over the past twenty-five years, and has long family associations with the towns of Stockton and Norton. Over the past four years, he has written books which cover most of the lower part of the Tees Valley; these include Middlesbrough, Billingham, Stockton and Cleveland. He has been the historical advisor on a number of projects, including Granada Television's In Suspicious Circumstances, starring the late Edward Woodward. He runs Image North East; a company dedicated to preserving the history and heritage of the region, and in 2010 was invited to write for the BFI's new regional Mediatheque project in Newcastle.

ACKNOWLEDGEMENTS

I give grateful thanks to all those individuals and organisations that have allowed me to copy and use their material, given of their time and generally helped in my research. I have taken a great deal of time tracing and establishing ownership of all material and ensuring that permission for reproduction in this work has been given, whether in copyright or not.

Permission to include images, map extracts and written material has been given by Alan McKinnell, who patiently allowed me access to his amazing collection of prints; Len Whitehouse; the staff at Middlesbrough Reference Library, particularly Larry Bruce back in the 1980s; Revd W. Wright; Jo Faulkner at Stockton-on-Tees Borough Council Museums Service; Steve Wild at Stockton Reference Library; the now defunct Cleveland County Council Planning Department; Mark Rowland-Jones; David Tyrell; Janet Baker; Stuart Pacitto; Anne Thirsk and Debbi Dale, stalwarts of Teesside Archives, without whose kindness and patience this book would not have been possible; the late Adrian Ward Jackson, who very kindly sent copies of Ralph Jackson's diaries as well as images of the Jackson family before his untimely death in 1991; Alan Sims at the *Evening Gazette* Teesside; Alan Betteney, and Steve Hearn at the Ordnance Survey. Other material is from the author's own collection, and of course Matilda Richards, my editor at The History Press who has offered such good support during the writing of this work.

If there are any unmentioned sources here I offer my thanks as well as my apologies for failing to mention them by name. One other name I need to mention is the late Ken Warne. When Ken died in January 2011, aged 104, the world lost a remarkable person, a living link with Teesside in the years before the First World War. I was privileged to spend time with Ken as he talked about his childhood days in Eaglescliffe and Yarm; interviews which I am pleased to say are recorded forever on video.

INTRODUCTION

Writing a history of Stockton has been a true labour of love – it is after all the town where I was born way back in the early 1950s. Although I have never lived in the town itself, I have many fond memories of accompanying my grandparents on their weekly visit to the bustling Stockton market and the steep walk down Finkle Street to Mellor's Pet Shop (housed in one of the old Georgian buildings now no more), where my grandfather bought feed for the chickens kept in their garden. At the end of Finkle Street (one of the oldest parts of the town) was the river, where water lapped around rotting staithes, which were a reminder of more prosperous days. Walking along the High Street, one glimpsed the tangled maze of old yards and narrow pathways that stretched down to the river – dark and ghostly on a wet November afternoon to a young boy like me. It was all very atmospheric but I acknowledge now the air of decay and dereliction.

I can visualise the scene today as I write these word; I give thanks for being blessed with such a photographic memory because this area, like a great deal of Old Stockton, has been consigned to history. A shopping centre, visually sterile, stands as a replacement for the historic old buildings that were razed to the ground as part of the frenzy to modernise everything – including our architectural heritage in the late 1960s and 1970s. Even allowing for the advantage of hindsight, were these concrete edifices ever a worthy addition to our rich urban landscape? The town has changed, there is no going back – but memories live on; as a historian it is my job to celebrate this heritage through this work.

The images presented here recall a time when Stockton was able to challenge Middlesbrough as a regional and retail centre, four centuries ago. Citizens of Stockton across the generations have been used to this idea of challenge and counter-challenge. After all, 400 years ago, Stockton began to dominate the lower Tees Valley as an economic centre, leaving Yarm to face a less important role thereafter. The boot was on the other foot from 1830, when Stockton faced the prospect of Middlesbrough not only challenging, but ultimately replacing Stockton as the main town in the region. Unlike Yarm, Stockton was better placed to respond to that challenge and considerable industrial development continued to bring growth to the town, although it never replaced Middlesbrough as the main regional centre. Just as Middlesbrough became a centre for the communities south of the Tees, Stockton did however retain its prominence as a centre of regional life in South Durham.

Like Middlesborough, Stockton also had its share of Victorian entrepreneurs as industry developed along the river; with its shipyards and iron and steel works bringing employment to many. However, the inevitable economic cycles ultimately brought the demise of the old industries in Stockton, as it had done in Middlesborough. Now, as both towns face up to the hard reality of post-industrial life there is less insularity and boundaries are less distinct; communities still hold on to individual identities but necessity forces recognition of being part of a greater community, that of Teesside.

This work celebrates Stockton and, for the purposes of this book, this also means the borough of Stockton-on-Tees. Thus, Thornaby, Norton, Ingleby Barwick, Hartburn, Eaglescliffe, Egglescliffe and Yarm all have their place.

Over the past twenty-six years there have been immense strides forward with computer technology; an invaluable aid in improving not only the quality, but the range of images available. Many of the pictures used here have been digitally restored using Photoshop, in order to restore each one as closely as possible to its original state when first printed. Occasionally, in performing digital restoration, decisions have to be taken to include something which does not exist. It is hoped that where this is the case you will agree that the image has been sensitively restored. To allow more images to be included, scenes have been grouped together in multi-views, following in the style of the pioneer postcard publishers a century or more ago.

I have always been a historian 'by trade' through a university degree, and post-graduate study which led to my MA in history. My academic speciality – twentieth-century political history – ran parallel with an insatiable appetite for local history, and, in particular, the history of this region.

Writing of any nature always impacts on those people closest to you and this is the case here. I would like to offer an enormous thank you to my dear wife Jackie, who has had to put up with many months of my rising at five o'clock in the morning to write before going off to my other job, as well as my spending many rainy afternoons at the local archives and libraries.

While I have attempted to ensure that there are no obvious mistakes in this work, I would like to apologise in advance for any errors that have been made. Please let me know and I will update my records. In the same vein, if anyone has any more information or evidence regarding the history of Stockton and the communities around it which they would like to share with me, please get in touch – especially if you have any images that you will allow me to copy.

Paul Menzies, April 2011
m.menzies1@ntlworld.com

ONE

EARLY DAYS

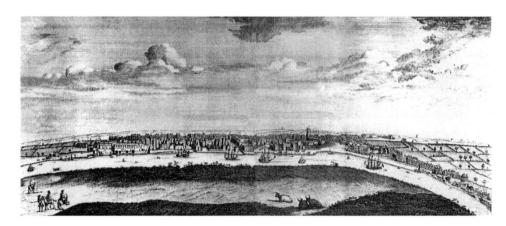

The pictures in this chapter depict Stockton in the days before the arrival of the railway in 1825. Relocating the Customs Office from Hartlepool to the Red Lion Yard in Stockton in 1680 reflected the growing importance of late seventeenth-century Stockton. This contemporary panorama, dating from around 1730, shows the town of Stockton from Thornaby Carrs. The Toll Booth, replaced by today's Town House in 1735, is visible along with Stockton parish church, which opened in 1712. This was a period of increasing prosperity for Stockton, bringing rebuilding and development to many parts of the town; as seen here between the High Street and the river. South of the town, close to the boathouse and ferry, stands the 'old castle barn', the only remaining part of Stockton Castle.

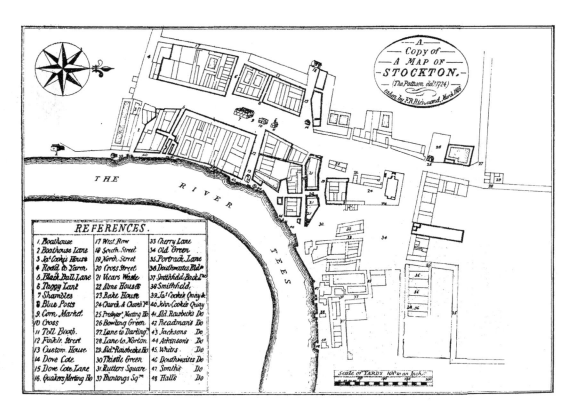

Taken from Thomas Pattison's plan of 1724, the full extent of Stockton at the time can be seen. West Row marked the western limit of the town. Travelling south meant using the ferry – the boathouse is clearly marked – or using Park Row, then Yarm Lane close to the southern boundary at the end of the High Street. The 'Tolbooth' [sic], with its small shops leased by the Bishop Durham, stands in the High Street close to the old market cross. Finkle Street and the Custom House are part of the development close to the river. The medieval Dove Cote stands at the entrance to Dove Cote Lane. Old Green and the road east to Portrack via Portrack Lane are visible close to the parish church, as is Thistle Green.

Opposite: Improved trade links with London and Northern Europe in particular meant that ships carrying lead, wool and hides from North Yorkshire brought back imports of timber and other raw materials to be used in Cleveland's thriving linen industry. In 1718, seventy-five corn ships entered the port of London from Stockton – more than from Hartlepool and Sunderland combined. This view looks towards the Bishop's Landing Place and the developing area east of the High Street. A new road linking Finkle Street and Castlegate was built in 1706; Silver and Bishop Streets (seen here) also date from this time. In 1730, the Customs Office, having already moved again in 1696, found a more permanent home close by the river; the £150 building costs being funded by the Corporation. The Town House, built in 1735, dominates the skyline along with the parish church.

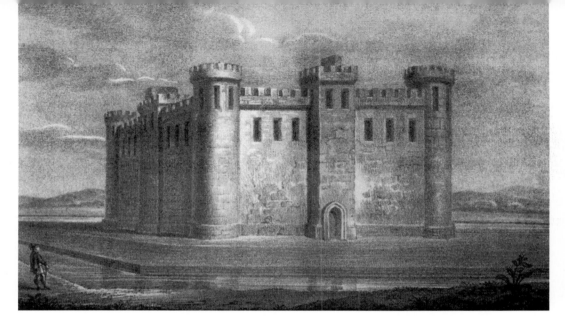

Stockton dates back to at least the twelfth century, when it was one of a number of small settlements in the Boldon Book of 1183, noted within the parish of Norton. There is also reference to a fortified manor house for the use of the Bishop of Durham. Evidence from excavations in the 1960s suggests an impressive structure evident in this old drawing, showing four main towers probably linked by blocks containing residential facilities. King John stayed there in 1214 when he signed a charter for the burgesses at Newcastle. By 1376, it was known as Stockton Castle, with further development taking place in the fifteenth century. Soldiers were garrisoned there in 1543 following the Pilgrimage of Grace and again in 1640, when Royalist forces were placed there. The castle remained a Royalist stronghold during the Civil War until it was taken by the Scots in 1644 under the Earl of Callendar, after the Battle of Marston Moor. In 1647, by Order of Parliament, the building was destroyed, except for the castle barn – later described as a 'castellated cowhouse' – which survived until its demolition on 29 June 1865.

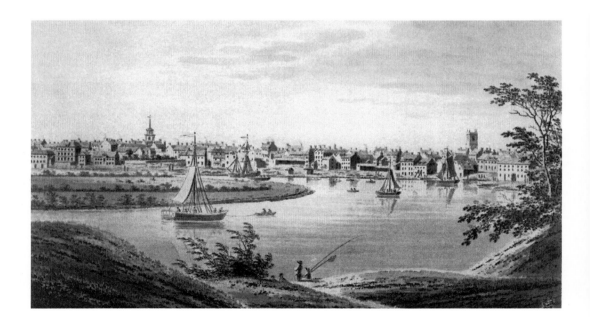

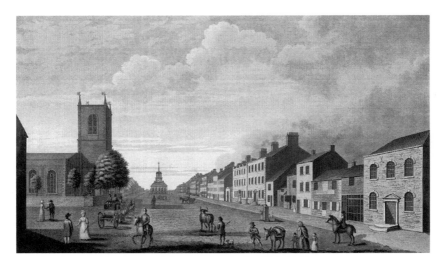

Despite the Seven Years War and conflicts with America and France, the town increasingly became a social and economic centre throughout the eighteenth century. Prosperity brought improvements to the town. A new parish church was built in 1712 and the Corporation of Stockton ordered the paving of streets in 1717. The centuries old 'Tolbooth' [sic] was replaced by the elegant new Town House in 1735. Both buildings are visible in this image from 1785. The High Street was the socio-economic centre of the town, with many residential buildings as well as those used for commercial purposes.

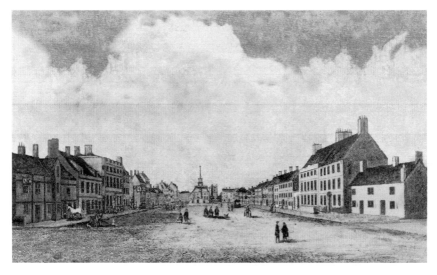

This photograph, again from 1785, shows the High Street viewed from the south. With no bridge across the river at this time, travellers heading south either used the ferry or entered Park Row and Yarm Lane from the end of the High Street. Many of the brick buildings, as seen here, were part of the general rebuilding that took place in the post-Reformation period, replacing the old wattle and daub structures that existed before.

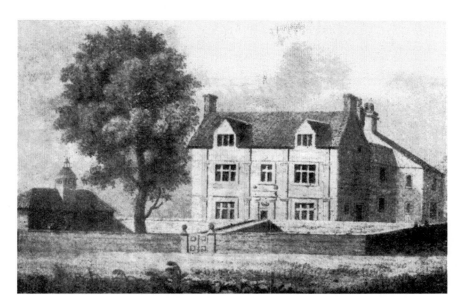

Major John Jenkins was a Welshman in Cromwell's Army, which arrived in Stockton towards the end of the Civil War. When hostilities ended, Jenkins remained in the town and had this elegant house built at the north end of the High Street, on the lane to Norton. He died in 1661, his will stipulating that one shilling should be used to purchase white bread to be given to the poor in the parish church every Sunday.

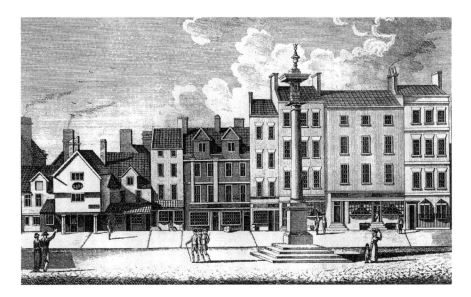

This view looking towards the western side of the High Street is dominated by the impressive market cross with its 35ft-high Doric column. It was built in 1768 at a cost of £45. Also visible is the Blue Posts Hotel, then one of the town's oldest buildings and said to have within its structure a pair of Frosterley marble posts thought to be from Stockton Castle.

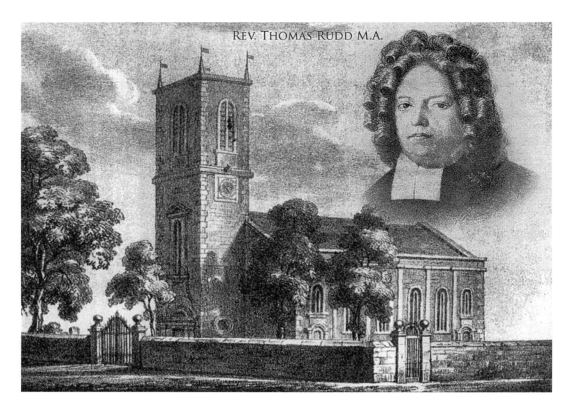

REV. THOMAS RUDD M.A.

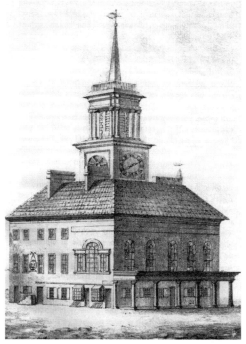

Above: A chapel of ease, dedicated to St Thomas à Becket, was built, close to the site of the parish church in 1235. By the late seventeenth century, this was falling into disrepair. It was felt that the general development of the town merited a new church, a proposal very much driven by the Revd Thomas Rudd, who had arrived at the chapel in 1663. Building began in 1710 and on 20 March 1712 the first sermon was preached by Rudd himself, although the first vicar at the new church was the Revd George Gibson. Further development included a west gallery in 1719, a north gallery in 1748 and a south gallery in 1827, The clock and chimes were added in 1759.

Left: Hatfield's survey of 1384 indicates that the Mayor's House had once stood on this site; by the seventeenth-century part of the building was being used as a tollbooth, described by Brewster as 'a mean building, ascended by steps and built on open arches'. As a mark of the town's general progress, an impressive Town House was built in 1735, with four bow-fronted shops, an inn and cellars being added in 1744. This view from the north east shows the piazza, a further addition to the original building.

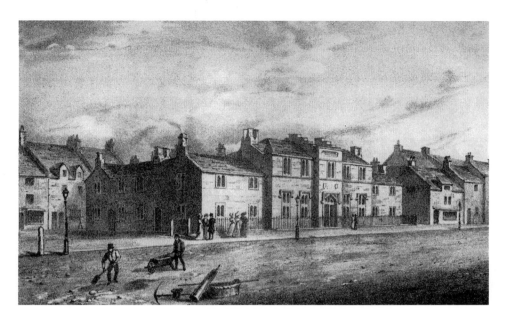

The demolition of the old Stockton almshouses (built in 1682) started on 1 July 1816. By 1829, they had been replaced by the new almshouses shown here. The project was financed by a bequest of £3,000 from George Brown, a citizen and wealthy benefactor of the town. The new almshouses, built close to the parish church, were in Gothic style with a committee room, dispensary and accommodation for up to thirty-six widows and their families.

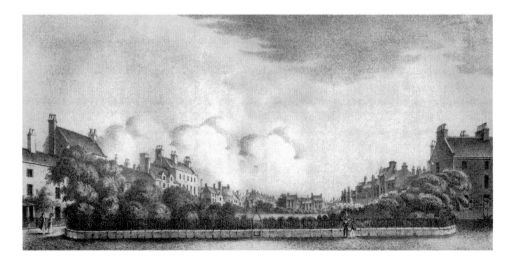

When the parish church was built in 1712, a piece of wasteland was purchased for a new vicarage. As the vicarage was never built the land became a garden or 'Green'. It was renamed 'The Square' to avoid confusion with nearby Thistle Green. Surrounded by wooden railings and bushes, The Square became a very fashionable part of Stockton in the Georgian period. A theatre opened in nearby Green Dragon Yard in 1766. In this image dating from around 1829, Church Row is on the left, Paradise Row is in the distance and the road to Thistle Green is on the right.

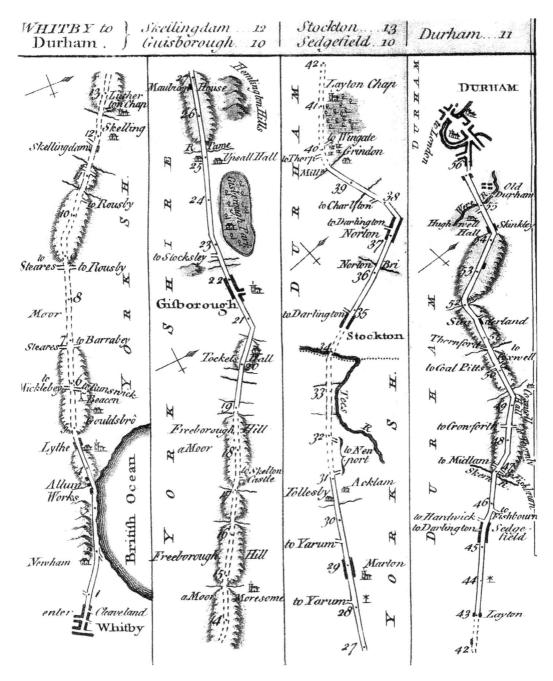

This map from 1769 shows the route from Whitby to Durham which, with the construction of the new bridge over the Tees, could now go via Stockton rather than Yarm. Note that beyond Stockton the route went through Norton village and up to Sedgefield. Roads in the area were generally improving at this time, including the opening of the turnpike from Norton to Sunderland, via Billingham and Castle Eden, in 1789.

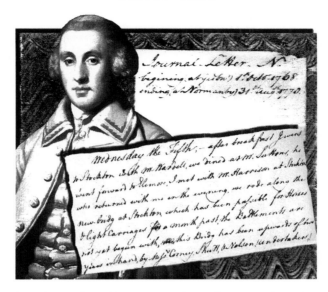

Ralph Jackson of Guisborough and later Normanby Hall, wrote a diary from 1749 to 1790. His daily entries offer an insight into eighteenth-century life in Teesside, including many visits to Stockton to conduct his business and social affairs. From Jackson's diary, it is clear that the town was a growing community. He mentions contemporary events, and notable citizens like George Sutton, Mayor in 1759, 1760 and 1768 as well as tradesmen like shoemaker, Jas. Grey. It is the ordinary detail that brings the diary to life; for example, on 5 February 1757, Jackson writes that John Johnson, the 'Stockton Carrier', told him that the frost at Stockton was so great that horses 'went over the ice upon the Tees'.

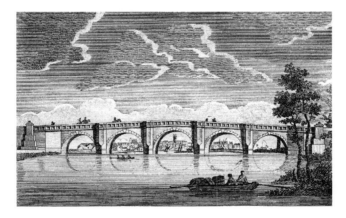

The ferry service at the site of the old castle was inadequate for a growing town. Therefore, an impressive five-arched stone bridge was officially opened in 1771, saving six miles for travellers who no longer had to use the bridge at Yarm. Tolls financed the £8,000 building costs. The Trust who had financed the bridge were eager to recoup their money and opened the bridge early as noted by Ralph Jackson on 5 October 1768, when in his diary he wrote, 'rode along the New-bridg [sic] at Stockton, which has been passible [sic] for Horses & light Carriages for a month past, (although) the Battlements are not yet begun.' The 'battlements' (buttresses) which Jackson is referring to can be seen in this view of the bridge, c. 1820. Following extensive public unrest at the continued use of the tolls, they were withdrawn in October 1819.

Stockton 1825

The Iron Bridge at Yarm

Old Yarm Bridge &
Egglescliffe Church

This image is taken from Christopher Greenwood's 1820 map of Durham. The local dominance of Hartlepool and Yarm as economic centres since the middle ages was being challenged by the increasing prosperity of Stockton in the eighteenth century. Expanding trade with London and Northern Europe brought demand for more ships, benefiting local ship-building and other subsidiary industries, a development which filtered into the regional economy as a whole. Improved land access to Stockton through the opening of Stockton Bridge in 1771, the creation of new turnpike roads and, in 1825, the Stockton to Darlington Railway, were crucial to the town's development. The land beyond Stockton to the sea was still largely undeveloped and isolated. Principal landowners included the Church and wealthy individuals such as the Marquess of Londonderry at Wynyard.

The two routes west from Stockton to Darlington – Bishopton Lane and Oxbridge Lane – converged west of the town at Two Mile House, after which they continued to Darlington. Bishopton Lane can be seen here in the early nineteenth century. A chimney at Stockton Iron Works on West Row, built in 1765, and the windmill built in 1814 on Mill Lane (an extension of Dovecot Street) are visible on the horizon.

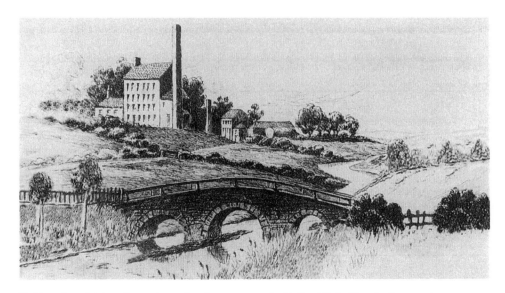

Unlike the eighteenth-century development east of the High Street, the west was more gradual. In the 1820s, Brunswick, Albion, Skinner, William and Lodge Streets were all built (*see* map on p.22). The rural nature of the area is shown in this image of Brown's Bridge, on Bishopton Lane, less than a mile from the town. There had been a mill on Brown's Haugh since 1786, when it was owned by William Smith. In 1832 it was sold to Tommy Wren and is visible here in the distance.

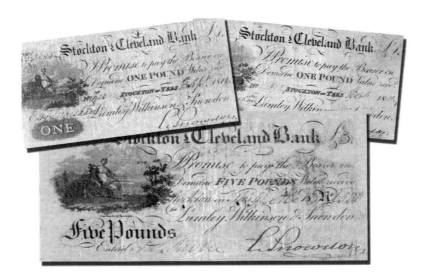

Many towns had their own banks that issued their own notes. These notes were issued by Lumley & Co. (Stockton and Cleveland Bank) in the early nineteenth century. Richmond records that they stopped business on 27 July 1815 and appeared in the bankrupt list on 15 August 1815. The problems of issuing local currency are highlighted by Ralph Jackson in 1762 when he writes that in Stockton, 'bills were so scarce that I could only get £280 worth'.

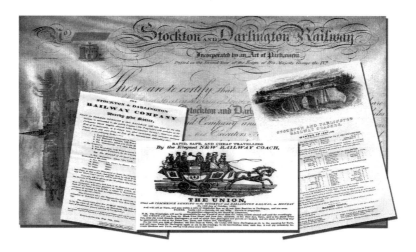

The rapid expansion of the West Durham coalfield in the late eighteenth century led to a need for a cost-efficient way to meet the growing demand from markets beyond the region. With insufficient support for a proposed canal scheme, a railway from the coalfield to Stockton won the day. The opening of the Stockton and Darlington Railway on 27 September 1825 was a milestone in the development of the town. Shown are some of the memorabilia from the period, including a share certificate (back), formal notification of the opening, a poster for 'The Union' – a railway coach service which began in October 1826 – and a timetable for 1837 by which time passenger services were well established.

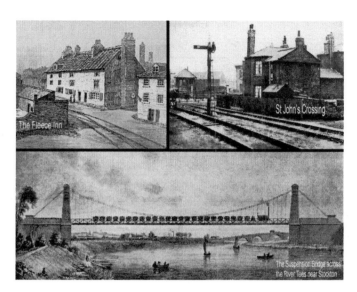

St John's Crossing (top right) was where the first iron rails were laid on 23 May 1822 by Thomas Meynell, amidst scenes of great celebration. Three years later the railway opened, the project having cost the sixty shareholders £150,000 to finance. The Fleece Inn (top left), at the bottom of Castlegate, was where one of the early coaches ran from. The Stockton and Darlington Railway Suspension Bridge was built across the Tees close to Stockton by Samuel Brown, Esq. RN., when the railway was extended to Middlesbrough in 1831.

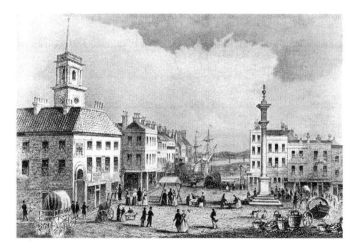

The mid-1820s brought two days of notable public celebration to Stockton. The formal opening of the Stockton and Darlington Railway on 27 September 1825 was followed on Monday, 24 September 1827 with a visit by the Duke of Wellington, who was greeted by a nineteen-gun salute and the ringing of church bells. This contemporary illustration shows the town at that time: a flourishing market place, elegant Town House and stylish market cross flanked by many fine buildings. The market place looks down Finkle Street to the River Tees and the distant 'Janny Mills' Island. This was one of several islands and sandbanks in the Tees which existed before the river was straightened and improved.

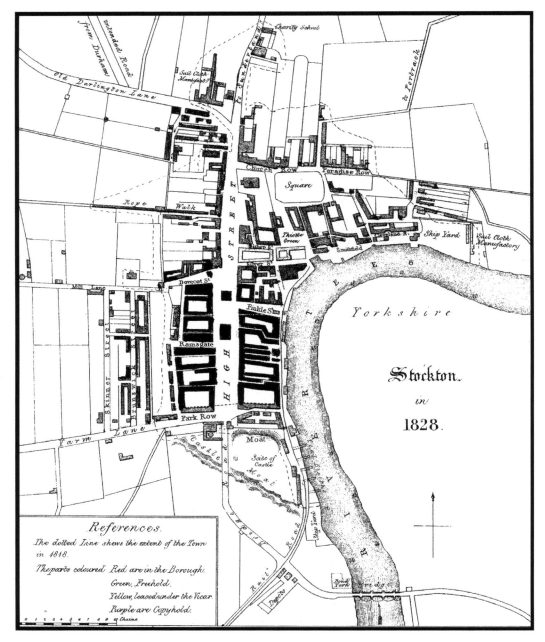

By 1828, when this map was drawn, Stockton's economic development was in full flow; five coal staiths are shown next to the railway as well as two shipyards and two sailcloth manufacturers – one next to the river and one close to the town on Old Darlington Lane (now Brown's Bridge Lane). Previously, new housing had tended to be infilling in populated areas but now, for the first time, there was development west of the High Street, which was beyond the old boundaries, a portent of future expansion. The site of Stockton Castle is shown along with the old moat and castellated outbuilding, used at this time for agricultural purposes.

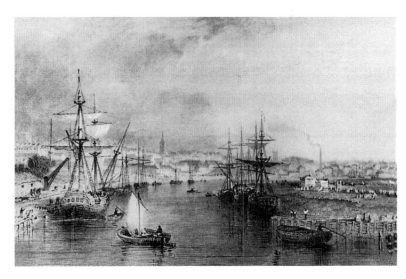

Much of the expanding economic activity was along the riverside. A horse-drawn carriage can be seen here in about 1832 operating on the Stockton and Darlington Railway, close to Cottage Row, while a ship berthed at the coal-staiths is taking on a fresh cargo. A number of other ships are also berthed at more distant wharfs. Both the Town House and the parish church are visible on the skyline, as is a chimney from a sail-cloth factory near Thistle Green. Across the river on Mandale Carrs, is the grandstand of Stockton Racecourse, the venue for a number of years for the town's race meetings.

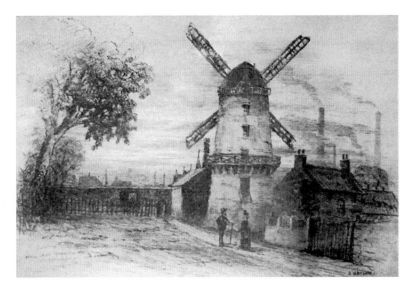

A mill was built close to the end of Dovecot Street by John Tweddell, a millwright, and opened on 10 January 1814. The map of 1828 (see opposite) clearly shows the site of the mill and two other buildings, probably a house and granary, on the north side of the road beyond Dovecot Street, noted as Mill Lane. The west side of Stockton was an area of development at that time. This drawing shows Stockton Iron Works in the distance.

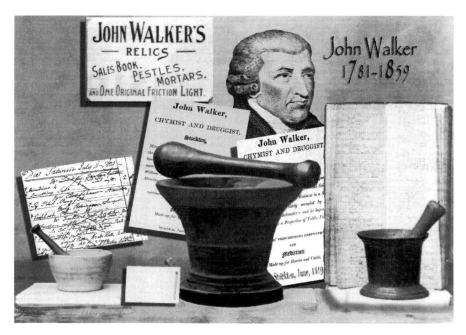

John Walker (1781-1859) is remembered for his invention of the 'friction light', although his failure to patent the design (despite encouragement from eminent scientists such as Michael Faraday) meant his financial rewards were small. Walker was born at 104 High Street, Stockton, and went on to qualify as a surgeon in London before returning to the town as a chemist and druggist – opening premises at 58-59 High Street. It was here that he successfully developed his 'friction light' in 1826. He remained in business until 1858, living in The Square for many years. These artefacts are from an exhibition held at his premises in 1927.

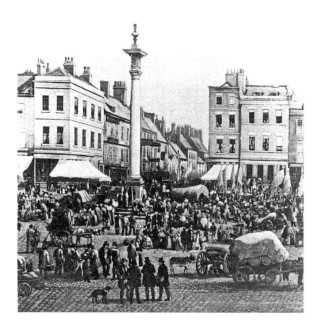

Left: This painting, 'Market Day' 1844, shows just how busy the town had become in the mid-nineteenth century. Crowds of people and wagons laden with goods gather around the Doric Cross. In the background lies Finkle Street and a busy riverside.

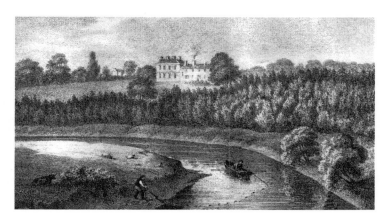

Preston Hall has stood on the banks of the River Tees in the parish of Preston-on-Tees for nearly 200 years. An impressive vision, it was one of several 'country seats' in Cleveland – some long established, others less so. Preston Hall was the latter – David Burton Fowler, a lawyer, only acquired the land at Preston on which to build the Hall in 1820. The location was well chosen; when the work was completed in 1825, Preston Hall was much admired for its fine view across the bend in the river to Thornaby woods and the distant Cleveland Hills. The original entrance to the Hall, facing the river, took full advantage of this vista, although it changed later when today's entrance was built. David Fowler died aged ninety-two on 30 January 1828 and the Hall passed to his nephew, Marshall Fowler. A point of interest is that the Stockton and Darlington Railway ran through the grounds of Preston Hall until 1852, when it was diverted through Eaglescliffe.

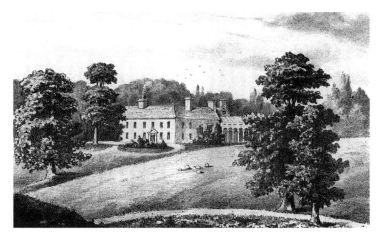

Elton Hall, seen here with its eighteenth-century facade, Venetian window, elegant conservatory and landscaped grounds, was described by Brewster in the 1820s as a modern mansion with a beautiful situation and grounds. Once owned by the Shafto's of Whitworth, Elton Hall had by the late eighteenth century passed to George Sutton, former mayor of Stockton. Sutton enlarged it and oversaw the landscaping of the grounds, although further alterations and extensions were made in 1829 after it had passed to his nephew, George William Sutton. It was George William Sutton's son, John Stapleton Sutton, who sold Elton Hall in 1900 to Thomas Appleby. After Appleby died in 1910, the Hall was demolished and replaced in 1912 by the current Edwardian building. It was eventually sold in 1925 to Robert Ropner.

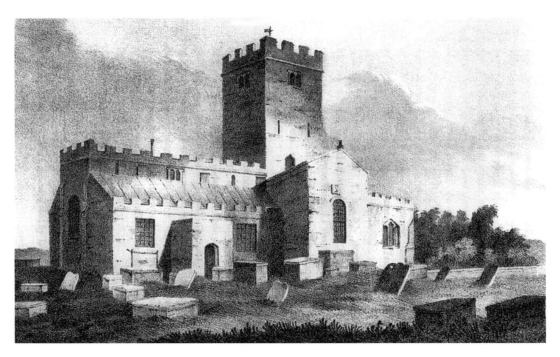

St Mary's Church at Norton-on-Tees was an important part of the early history of Stockton, acting as a 'mother church' to the townspeople until a chapel of ease, dedicated to St Thomas a Becket, was built at Stockton in 1235, close to the site of the parish church. This drawing is from the 1820s and shows the elegance of the church building at Norton.

TWO

THE HIGH STREET

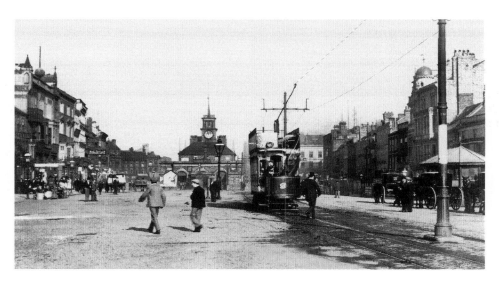

For over 700 years, the historic High Street and its market have been a key feature of life in Stockton. This snapshot shows Stockton High Street at five to eleven on a busy morning just over a century ago. The scene captures in detail people going about their daily lives, seemingly oblivious to being captured on film. The No. 9 tram moves slowly, by passing a line of handsome cabs waiting for their next fare outside the Unicorn Hotel.

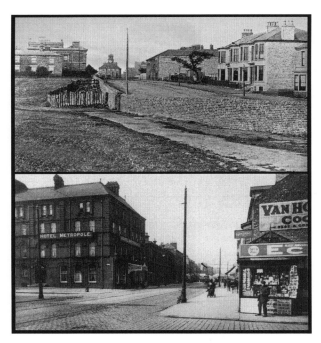

Originally, the High Street was closed at its southern end by the gates of Castle Park, but the opening of the new bridge in 1769 necessitated the adoption of a rough track to St John's Well, as a link to the town. In 1787, it became a country walk, lined by trees and ornamental hedgerows, along with seats and a white fence. 'The New Walk', as it was known locally, was very popular with walkers until it was widened in 1856 to accommodate increased traffic, renamed Bridge Road and subsequently built up. The upper image (1865) is taken where the old moat crossed the route, while the lower image, dated 1908, features the popular Hotel Metropole on Wood Street with Wharf Street on the right. The headline on the newspaper board is 'Mr Balfour's trenchant attack on the Budget.'

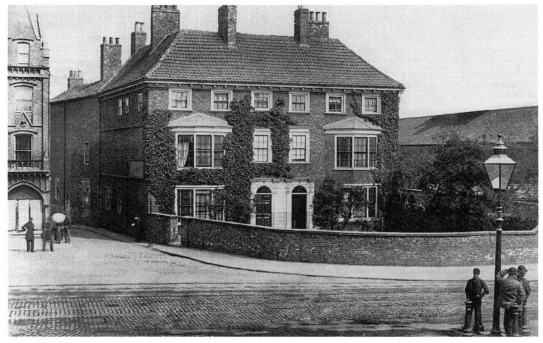

At the entrance to Bridge Road stood a large mansion known as Castlegate, parts of which were erected using stones reputedly from the ruined castle. Old plans show that the narrow garden ran down to the river. Eventually, the mansion was converted into the two ivy-covered cottages shown here. By the side of the property ran Castle Gate, a small lane down to the riverside.

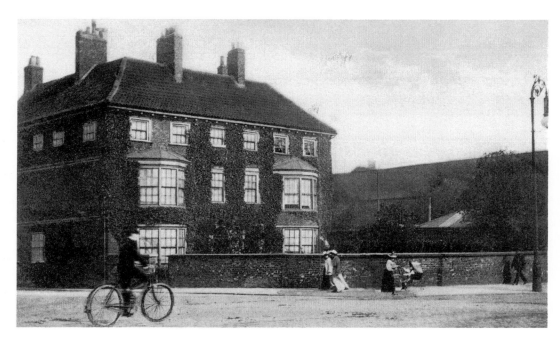

Beyond Castlegate can be seen buildings belonging to the Castle Brewery. It was this site that was the actual location of the old castle. In fact early Ordnance Survey maps refer to the site as 'Castle Field'. By 1900, this site was covered with rows of houses, familiar names such as Tower, Wharf and Moat Streets reflecting their link with the past.

Castlegate was demolished in 1907 to be replaced by the Castle Theatre. The foundation stone for the building was laid on 3 October 1907 by Richard Murray of Harrogate and the theatre opened on 31 July 1908, with a play called 'The Lady of Lyons'. Despite its elegant interior, featuring a white marble staircase and spectacular entrance, the Castle Theatre wasn't a financial success and it was renamed the Empire in 1912. The theatre survived until demolition in the 1970s, when the Swallow Hotel was built.

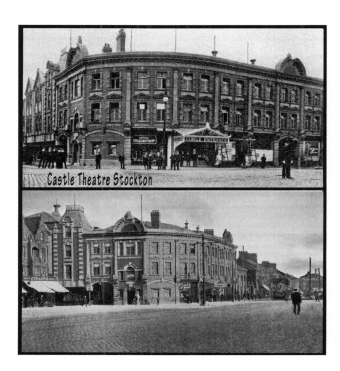

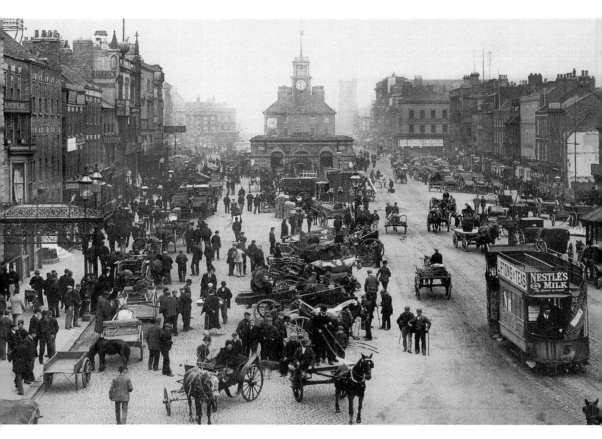

Towns like Stockton had become very busy centres by the late Victorian period, as shown by this image. A large number of horse-drawn carts and carriages are all vying for space along the High Street and it seems that there is little traffic order at all! A point of interest in this 1896 image is the steam tram, which was of the type that operated until electrification in 1898. On the western side of the High Street is the iron canopy which fronted the Borough Hall.

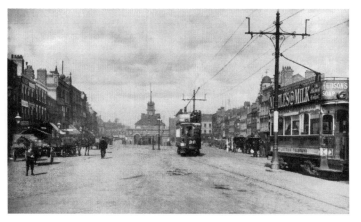

Another detailed image of the southern end of the High Street, with the Shambles and the Town Hall as its central focus. The electric trams came into operation in 1898 and ran from North Ormesby to Norton. There are glimpses of the many shops and trade premises that operated along the busy High Street while Dovecot Street can be seen in the distance.

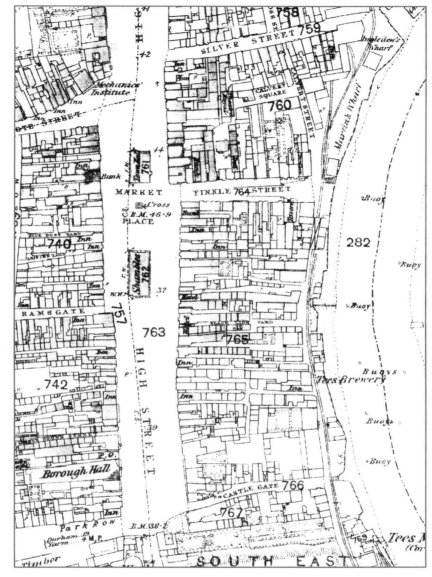

This plan from a revision of an 1857 Ordnance Survey map, provides a very detailed view of central Stockton 100 years ago. Comparison with the maps from 1724 and 1828 provides evidence of intense nineteenth-century development. Consider the vast maze of yards and other populated areas behind the frontages of the High Street buildings so familiar until the 1960s. Note: Park Row, a row of properties which once looked on to the farm in Castle Park, crossed by the footpath from the style at the end of West Row to the village of Preston-on-Tees. (Reproduced with the kind permission of the Ordnance Survey.)

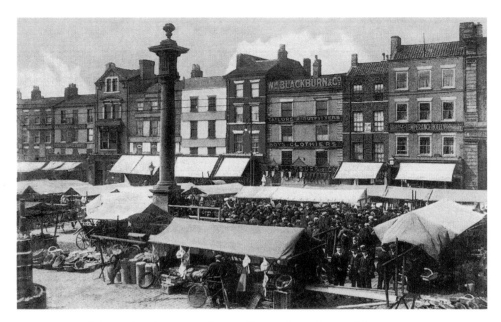

Despite many links with industry, Stockton still served a widespread farming community. One regular agricultural event was Stockton Hirings, shown here about 1908. These took place on two Wednesdays in May and two Wednesdays in November. Farmers employed their workers here for the next six months, the agreement being sealed with a Hiring Penny. This image shows a crowd of men around the Market Cross, surrounded by stalls from the twice-weekly market.

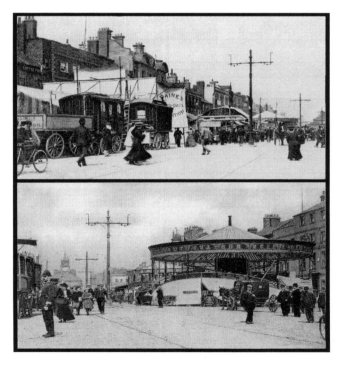

The Hirings were quite an occasion and gave many local traders a welcome boost to their takings. A fair with roundabouts, shooting booths and other amusements often accompanied the Hirings. For many of the farm labourers, this offered a rare visit to town so they often remained there for several days, many taking up lodgings in houses in Ramsgate at the cost of fourpence a night. Labourers often came from some distance; many – such as groups of Irish workers moved around the country seeking work where they could find it.

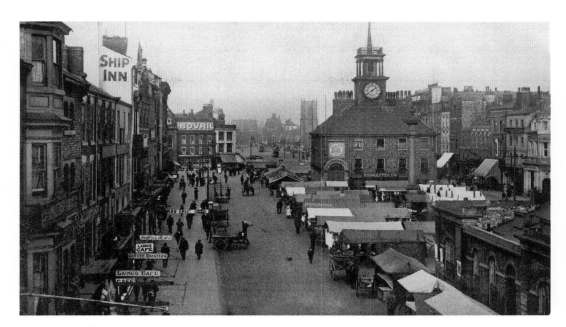

As we move up the High Street, this image shows the area between the Shambles and the Town Hall, populated by a variety of market stalls. The highly visible 'Bovril' sign adorns a building at the entrance to Dovecot Street, while the Ship Inn is in the foreground. A careful examination reveals a sign with the 'Blue Post Hotel' on it, close to the entrance to Blue Post Yard, one of many yards in this area. Not so easily visible is the entrance to Ship Inn Yard. The Town Hall premises of F. Collitt & Co., a wholesale and retail hardware, pottery and stationery business, are also visible facing the Market Cross.

This aerial photograph, from 1932 provides an excellent view of Stockton as it was in the late nineteenth century and early twentieth century. The High Street is shown, along with other local landmarks such as the parish church, the Town Hall and at the top of the image, Holy Trinity Church, Bridge Road and Victoria Bridge. Signs of change are evident though, with demolition already ongoing in the Thistle Green area between the parish church and the river.

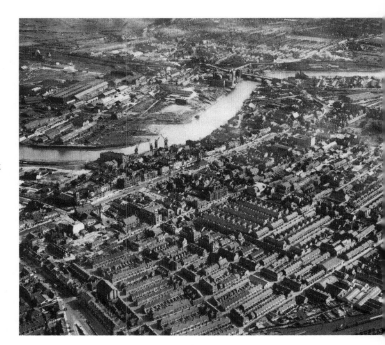

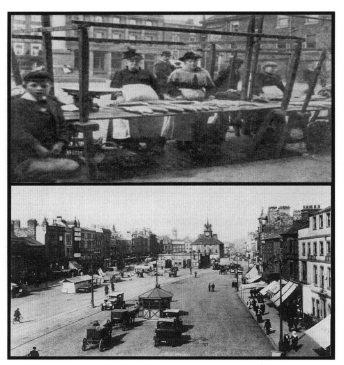

Stockton Market sold a variety of goods, including fresh food products, agricultural products and even small livestock. These ladies seen here around 1908, became something of a fixture in the Fish Market over the years and were renowned for the fresh fish they sold, particularly local salmon. Behind them are the Market Cross and Town Hall, both well known landmarks on Stockton High Street. The lower image is taken from outside the Royal Hotel, one of a number of hotels and inns along this part of the High Street in the early eighteenth century.

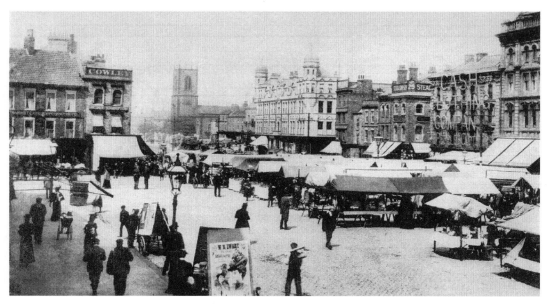

This view of Stockton's High Street is very familiar. Taken close to the start of Dovecot Street, it looks north towards the parish church and the many shops and commercial buildings that existed at this time. Stockton market is in full flow with a variety of stalls operating on most market days, attracting customers from a wide area. The Victoria Buildings, a replacement for the old almshouses can be seen close to the church.

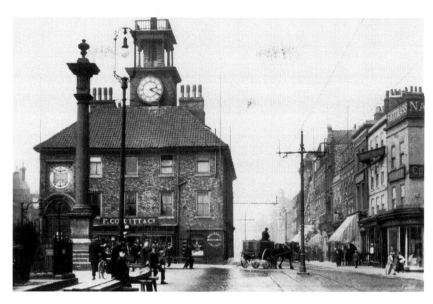

The High Street was a very dusty thoroughfare and often needed to be cleaned.
This photograph shows a water cart spraying the area close to the Town Hall and
Market Cross, *c.* 1908. Opposite is the corner of Finkle Street and Nattrass and
Grainger's home furnishing shop. Collitt's can also seen on what appears to be a
quiet afternoon in the town. As I write in 2011, the Town Hall clock, which had
operated since 1803, has recently undergone a full restoration.

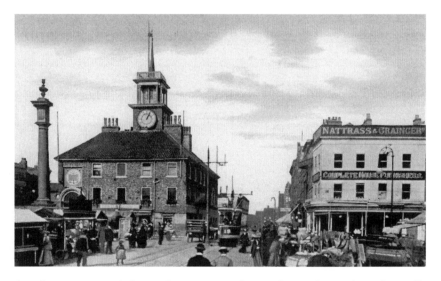

A wider panorama of almost the same view shows a busier day, with market stalls
around the Market Cross. In 2010, Stockton celebrated the 700th anniversary of
the signing of the charter allowing the town to hold its twice weekly market. As
ever, a tram is found in the image – they provided a very regular service running
along the route every six minutes.

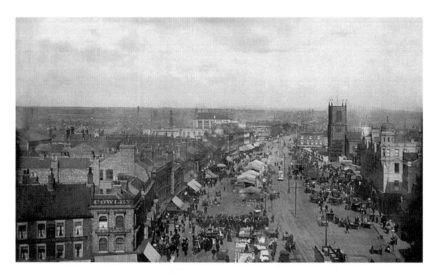

A fine view of the northern end of the High Street on Market Day, *c.* 1907. The image is taken from the end of Dovecot Street and looks towards the parish church and Church Row. In the foreground a large crowd of people suggests that Stockton Hirings could be taking place.

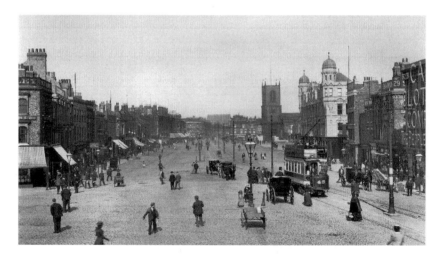

Taken from almost the same point, this detailed view, from about 1904, shows just how wide the cobbled High Street was. Hansom cabs trot along next to the no. 45 tram, while in the distance the western side of the High Street is dominated by the awnings of Matthias Robinson's Coliseum – one of the town's most popular retail stores. Bishopton Lane is visible beyond the store.

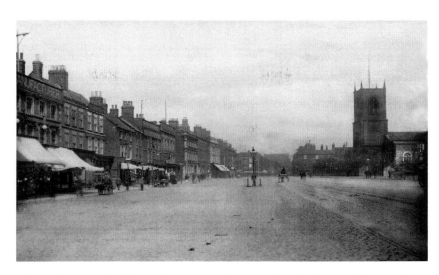

The northern end of the High Street is, for once, devoid of any traffic – perhaps this was taken very early on a Sunday morning? Only a lone cab and horse being walked along the cobbles can be found in this 1901 view, which looks towards Church Row and Bishopton Lane.

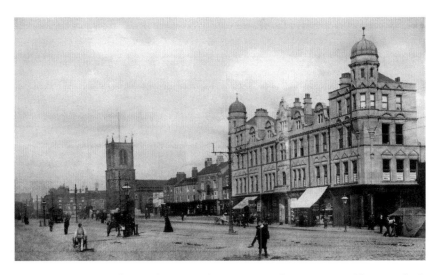

This 1901 image shows the recently constructed Victoria Buildings, which housed a number of retail premises. This late nineteenth century development replaced the old almhouses. The sixteen occupants of the almshouses were moved to another building on the corner of Dixon Street and Dovecote Street.

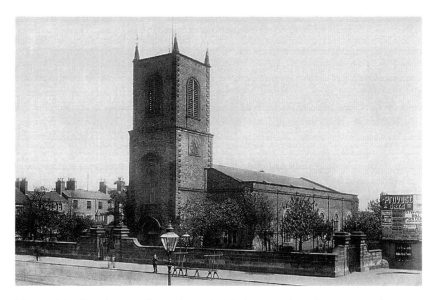

The parish church, seen here about 1896, has stood at the junction between
the High Street and Church Row for almost 300 years. It is thought that Sir
Christopher Wren may have advised on the design of the west tower. Several
improvements were carried out during the incumbency of Canon Martin from
1885, including the restoration of exterior stonework and the number of bells
being increased from six to ten. Canon Martin retired to Kelloe in 1916.

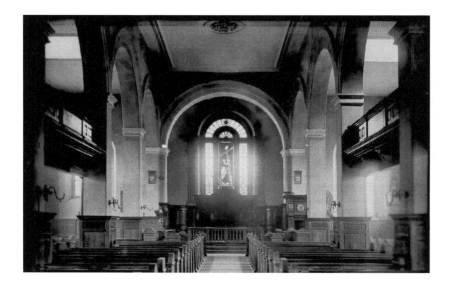

This view of the interior of the parish church in about 1896. As well as those
improvements mentioned already, the floor was re-wooded along with the removal
of high-pews to be replaced by open pews. The two galleries can be noted, date
from 1748 (left) and 1825 (right).

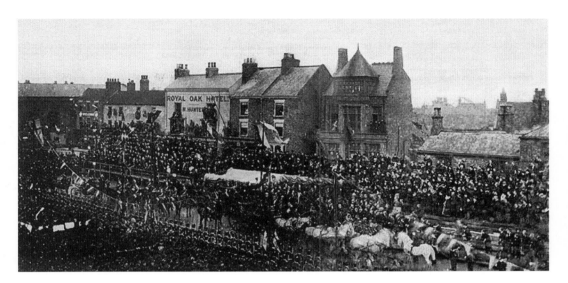

The Prince and Princess of Wales (later King Edward VII and Queen Alexandra) were welcomed to Stockton on 21 December 1883. The image was taken close to the Royal Oak public house. The royal visitors are in a coach pulled by four Windsor Greys, with an escort being provided by members of the Household Cavalry.

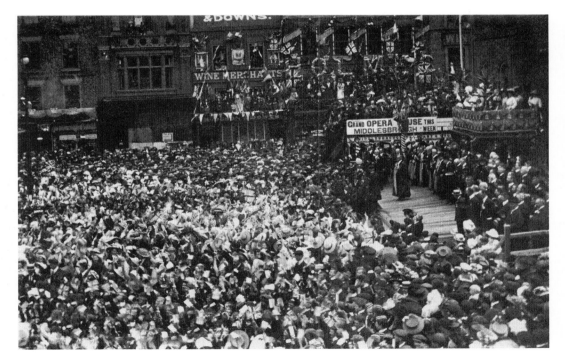

This image shows the crowds around the Town Hall on 22 June 1911, celebrating the Coronation of King George V. A point of interest is the tram in the midst of the crowd, which is carrying an advertisement for the Grand Opera House in Middlesbrough.

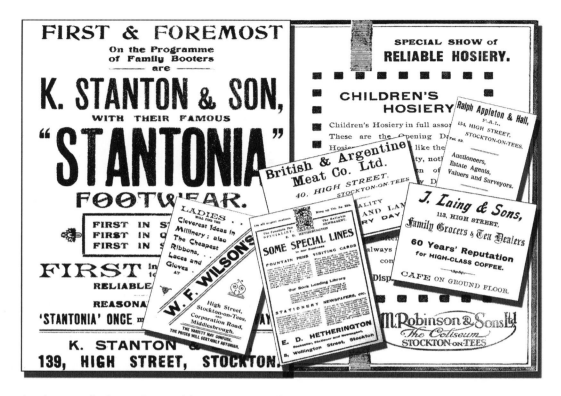

A selection of adverts for retail businesses in and around the High Street during the early 1900s.
Some names, including that of Appleton and Robinson, remained familiar to generations of people in
Stockton for many decades.

THREE

DOWN BY THE
RIVERSIDE

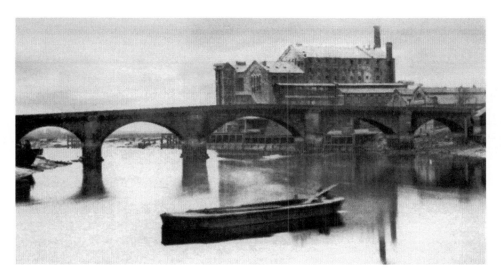

The economic development of Stockton from the eighteenth century has long been associated with the industrial development close to the River Tees. The building of the bridge at Stockton in the eighteenth century was a crucial factor in this development, as it provided access to a wide area beyond the river. This is a very rare image of the old bridge with its five arches in about 1886, just prior to its demolition to make way for the new Victoria Bridge. The Cleveland Flour Mill, built in 1871, can be seen beyond the bridge.

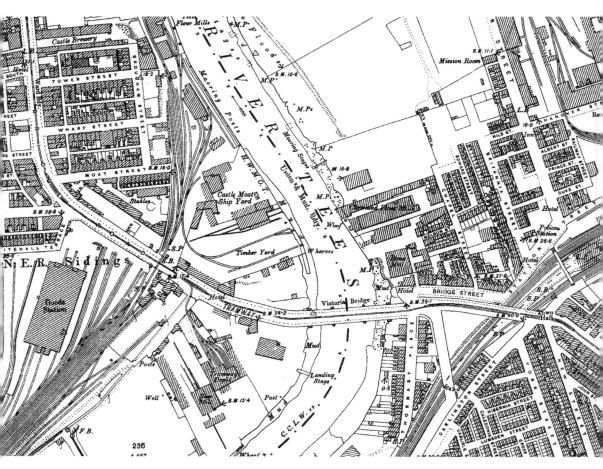

This map of the area around the Victoria Bridge shows just how developed it had become by the end of
the nineteenth century. Note the NER goods station with the old Stockton and Darlington line going to
the quayside. The Tramway Depot is also visible. as is the Castle Moat shipyard, one of the earliest in the
town. Beyond the bridge, the streets of the new development at Thornaby can be seen. (Reproduced with
the kind permission of the Ordnance Survey)

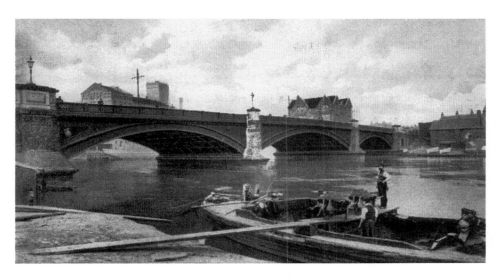

An excellent view of the Victoria Bridge shortly after it was built. Men on a working barge can be seen unloading sand. The increasing traffic using Stockton Bridge during the nineteenth century eventually led to it being replaced in 1887 by the Victoria Bridge. Costing £85,500, the new structure was much wider than the old bridge and could thus handle the increased traffic which used it. This image shows the bridge from the south, with the premises of the Cleveland Flour Mill Ltd (known as the Clevo Flour Mill) and the Bridge Hotel visible in the distance.

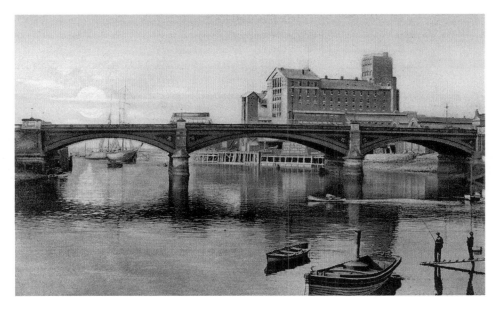

A tram crosses Victoria Bridge en route to Middlesbrough. Two fishermen in the foreground bring a degree of tranquillity to the scene. It is interesting to compare this view with that of the old bridge on p.41.

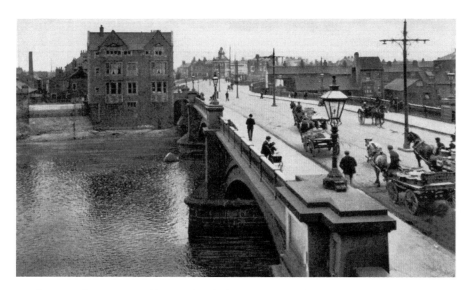

Until 1892, the municipal borough of Thornaby (seen here on the other side of the
Victoria Bridge) was known as South Stockton. This view from about 1904 shows
several horse-drawn vehicles on the bridge with Thornaby Town Hall in the distance.
The Bridge Hotel, built on the site of the old tollhouse (which collected tolls from the
earlier bridge), can also be seen.

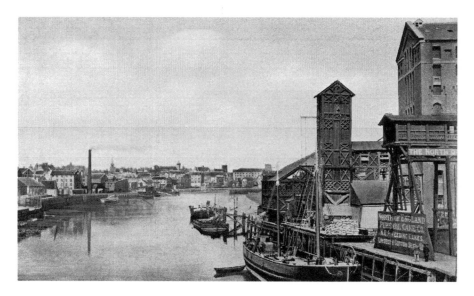

Looking downriver towards Stockton quayside, c.1906. A look along the skyline allows
us to note the Town Hall and the tower of the parish church. Along the riverside lie a
number of different quays and industrial buildings. In the foreground a boat is moored
at the quayside of the premises of the North of England Pure Oil Cake Company, which
opened here in 1869. Linseed and cotton seed were processed here as part of the
manufacture of a variety of cattle feeds.

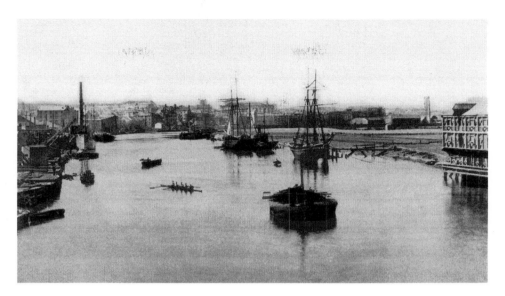

Another view looking downstream offers more detail of the riverside itself. A number of ships are moored at the quayside, with cranes unloading cargo recently brought to the port. Opposite is the area where shipyards, such as Craig Taylors, were based. Note the steam-powered paddleboat and behind it across the river, the large building which is Waterloo Mills, originally built in 1780 to house plant for the refining of crude imported sugar. The schooner in the foreground may be the *Young Hudson*.

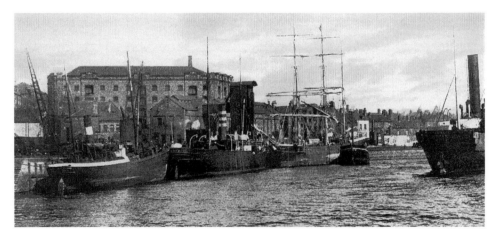

A busy shipping scene close to where the river turns eastwards, dominated again by Waterloo Mills. This scene, with old sailing ships moored alongside steam-driven vessels, shows just how busy the quayside at Stockton once was. Corporation Wharf is in the foreground while Thistle Green is close by. Further down riverhouses seem to tumble down towards the riverside at Hubbacks Quay – this whole area, with its crowded yards created during the infilling of the nineteenth century, was heavily criticised as being unsuitable to live in by the Ranger Report in 1850.

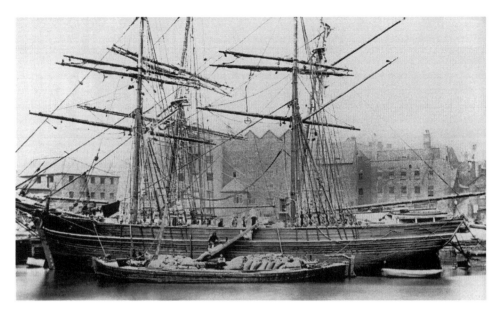

This image from about 1870 shows an unnamed ship moored at Corporation Quay, seemingly taking onboard a fresh cargo. Behind the vessel are a number of industrial buildings, essential to the functioning of the port.

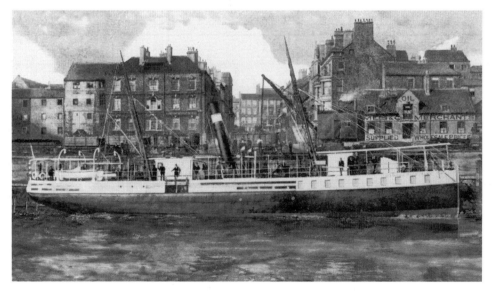

Stockton remained a reasonably busy port well into the twentieth century. One of the main wharves was Corporation Wharf, shown here in about 1906. The ship, *Manoela Victoriano*, is at its mooring with Finkle Street leading to the High Street visible behind. One of Stockton's best-known quayside buildings, the Custom House Hotel, is also visible, as are the warehouse premises of Raimes & Co., oil and paint merchants. The Raimes family owned Hartburn Lodge, a substantial property in east Hartburn.

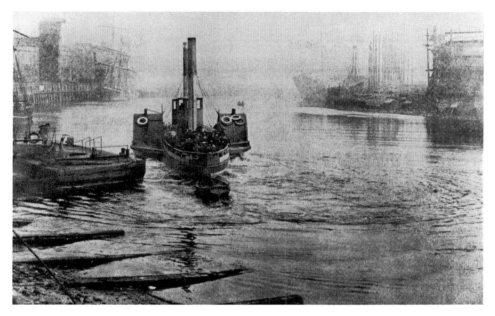

This image dates from the 1890s and shows *Old Glory*, one of the steam-powered paddleboats that operated between Middlesbrough to Stockton. At this time, there was still no bridging point below Stockton, so these ferry services were very popular in linking the towns.

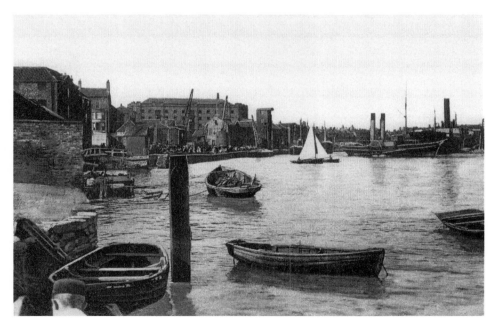

This detailed picture looks across the river from Kelly's Ferry landing at Stockton. On this riverbank there are steps going down to the river, while a paddlesteamer is close to the landing stage on the Thornaby side of the river, close to the stocks at the Craig Taylor shipyard. Corporation Wharf dominates mid-picture.

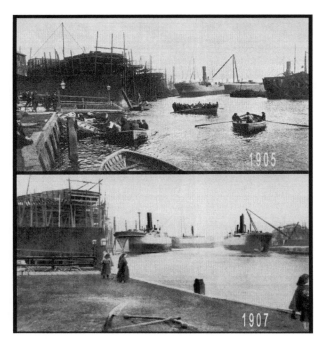

These two images show the site of Kelly's Ferry, which operated from an inlet close to Thistle Green across to the end of Trafalgar Street at Thornaby. The ferry is best remembered for ferrying workers from Stockton to the iron foundries and shipyards at Thornaby. Two landing stages were used at Stockton (for low and high tide) but a long set of steps served both tides at Thornaby. A brush was used to clean away silt left by the receding water, but it was not unknown for a hurrying worker to slip and fall in the river! The crossing was often described as 'nerve-racking' as boats carried up to sixty men – bringing the water level to just below the edge of the boat. As industry at Thornaby declined, so too did the need for the ferry.

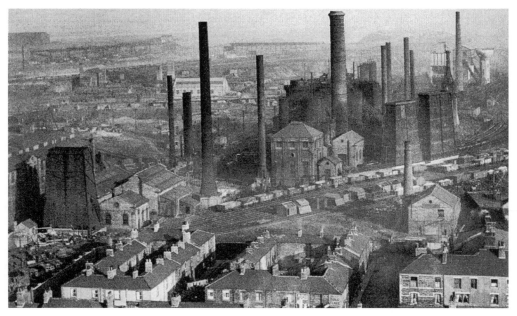

Two examples of the iron works at Thornaby can be seen here – the Teesdale Engineering Works (later Head Wrightson) and Thornaby Iron Works (later Whitwell & Co.). Both became established in the mid-nineteenth century, part of the vast number of iron works that opened at this time along the south bank of the Tees. By 1897, 1,000 Whitwells employees and an output of over 125,000 tons of pig iron. In the foreground, Trafalgar Street can be seen with a line of washing hanging out to dry.

An extract from an order at Richardson Duck & Co. shipyard on 10 September 1891 for the steel ship *The Highfields*. These were busy years for the shipyards in Stockton, with Richardson's yard building twenty-four vessels in the period 1891-1892 and eight being built at Craig Taylor's yard. The Richardson Duck yard first opened in 1854.

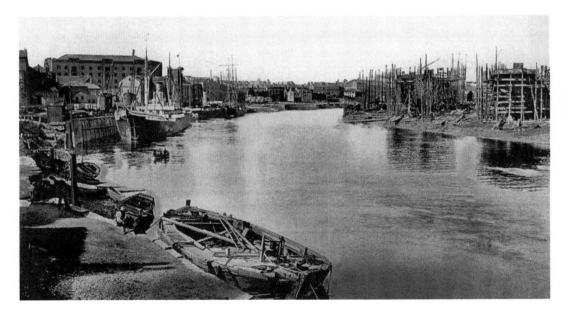

Barges, sailing ships and iron vessels can be seen here, illustrating the variety of ships using the port in the early 1900s. Hubback's Quay lies in the distance, with the Ship Launch public house visible on the distant riverside.

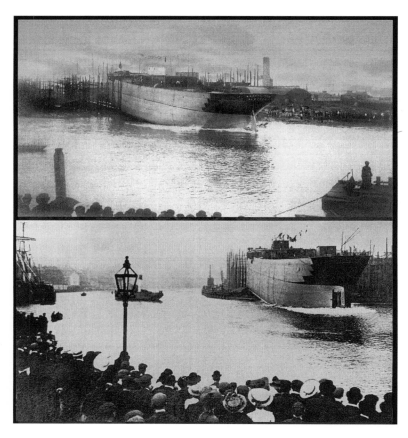

The launch of a ship from one of the yards was always a popular event, attracting crowds of local people. These images show two launches at the Craig Taylor yard: above is the *Rosecliffe*, launched on 23 July 1888, whilst below another launch takes place in 1910, watched by a huge crowd.

Below is the launch of the *Kilsyth* on 10 August 1903, a vessel with a gross tonnage of 2,142 tons.

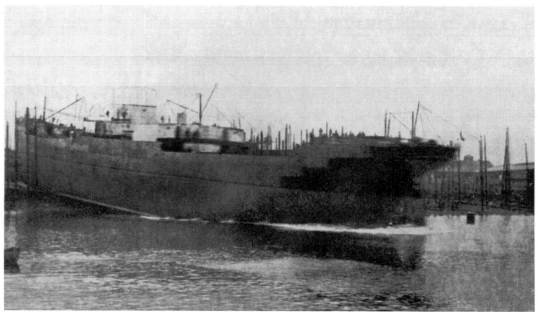

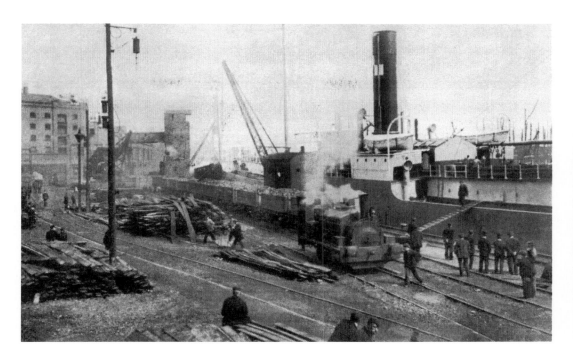

Cargo is being unloaded from a ship into wagons on the railway line which ran along the quayside at Stockton. A number of men stand around the steam loco as it waits for the signal to move – this line went past the NER 'Goods' Station and then joined with the main line south of the town.

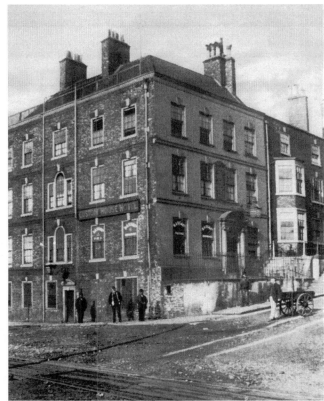

The Custom House Hotel opened in 1730 and stood at the bottom of Finkle Street. The large building dominated this area of the quayside for many years. The steep incline of Finkle Street can be gauged by the man with the handcart as he walks down the hill towards the quayside railway line.

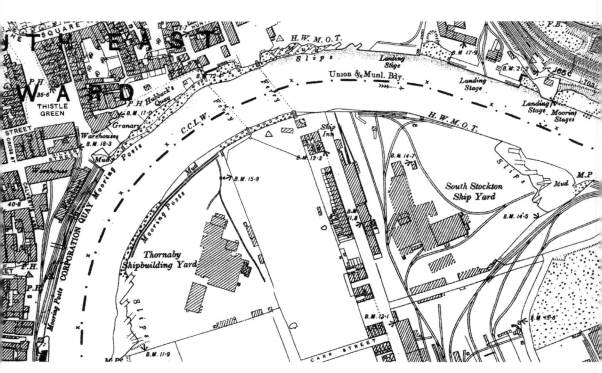

This map extract shows the main quayside area in detail. The ferry routes across the river can be noted as can the two shipyards – Thornaby Shipbuilding (Craig Taylor established here in 1884) and South Stockton (later Richardson Duck & Co.). It is interesting to note the proximity of residential properties to local industry – a common phenomena in the Victorian era; many of the properties shown here, particularly those around Thistle Green, were the first to be demolished under the slum clearance operation of the 1920s. (Reproduced with the kind permission of the Ordnance Survey)

Opposite above: Once known as the Blue Anchor Tavern, the Baltic Tavern was one of many public houses in this area. Drawing customers from those who lived and worked in the riverside area, these public houses would have been crowded, lively places during the years when industry was at its peak in Stockton. The incline to Thistle Green, by the side of the inn, was known as 'Sugar House Open' – a reference to the eighteenth-century sugar import trade. A closer look at the advertisement boards on the side of the granary building allows us to confirm the date of this image – 1927, when Syd Chaplin was starring in *The Missing Link* at the local Globe Theatre.

Opposite below: Adjacent to the Baltic Tavern was Waterloo Mills. A sugar refinery built in 1780, it faced onto the Wrens, Sugarhouse and Blue Anchor Quays, a link with the import of unrefined sugar from the Colonies and the Baltic. It was later used as a warehouse and granary. The building is seen here in the final days before demolition in 1929. The slight incline at the side of the building went up to Thistle Green, an area which was also being cleared at this time.

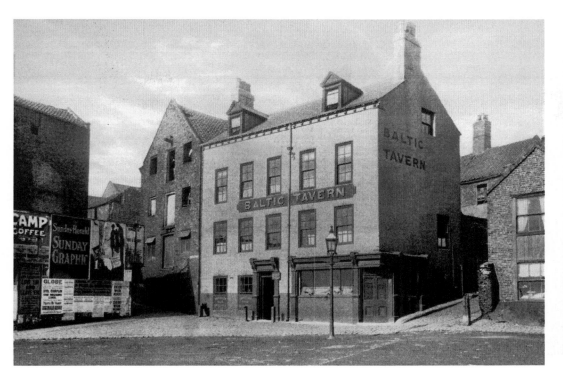

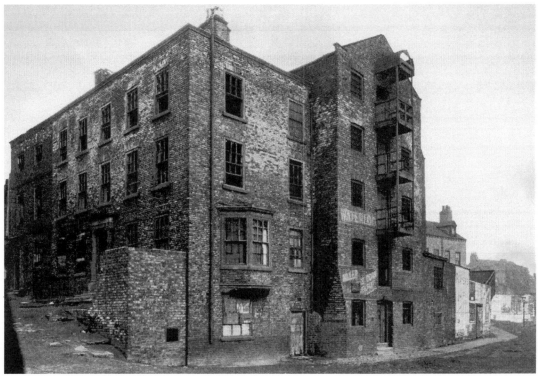

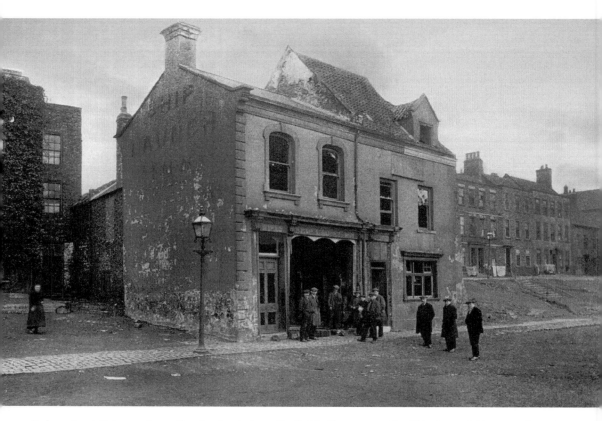

Only a short distance down the riverbank from the Baltic Tavern was the Ship Launch Inn seen here in 1928, when it too was part of the ongoing mass slum clearance. Beyond the inn are the terraced houses of Cleveland Row, built in the eighteenth century, while the ferry landing steps at the end of Smithfield are still in place. To the rear of the inn was Dixon's Yard, one of many in this area with unacceptable living conditions including little or no sanitation.

FOUR

AROUND TOWN

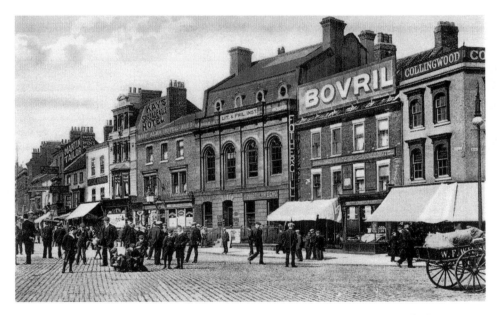

The nineteenth century brought expansion beyond the High Street and the river, a development which continued into the twentieth century. In this photograph, a crowd of men and boys stand at the entrance to Dovecot Street in about 1909 with the Alma Hotel and Stockton Literary and Philosophical Institute in the background. With the Spread Eagle Hotel adjacent to the Alma, competition for trade must have been fierce. Dovecot Street, one of the older streets in Stockton, linked to Mill Lane and Dovecot Mill.

Bowesfield Lane is seen here in about 1860, in one of the earliest existing images of the town. At that time it was called Love Lane. Before Holy Trinity Church was built, a footpath from the stile at the end of West Row went across the farmland, where William Wordsworth is said to have walked during visits to his wife's family. The footpath, an ancient track to Yarm, joined up with Love Lane close to where a large pond was situated.

The Heavisides family were one of the leading printing firms in Stockton. Michael Heavisides had originally started printing in 1777 in Darlington. His son, Henry, later opened a printing business in Stockton in 1856, using an iron press and iron rollers for inking. His son, Michael, had in turn taken over the business in 1870, using the latest technology. Both Henry and his son were also authors; Henry Heavisides had written The Annals of Stockton in 1865, and while Michael was the author of a number of publications about Stockton and the local area. At a time when leisure activities such as rambling and bicycle riding were increasingly fashionable, his guidebooks proved very popular. The company premises were located in Finkle Street.

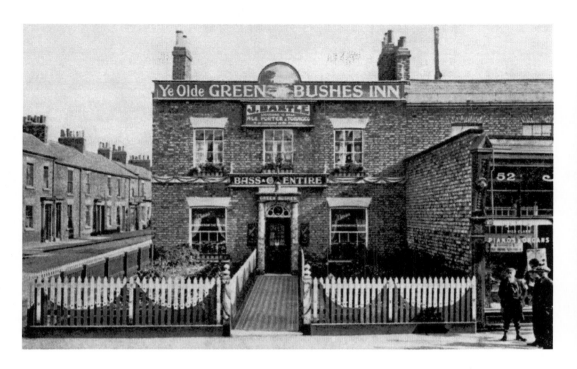

Ye Olde Green Bushes Inn, located in Yarm Lane close to the junction with Brunswick Street – seen here in about 1900.

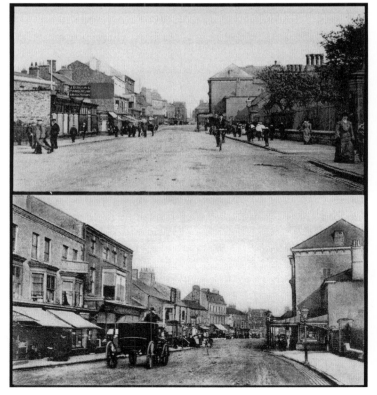

These two views look down Yarm Lane to the High Street. The upper image was taken outside the Green Bushes Inn, with Burdon's music shop on the left. Further down on the right, the canopy outside the New Theatre Royal can be seen.

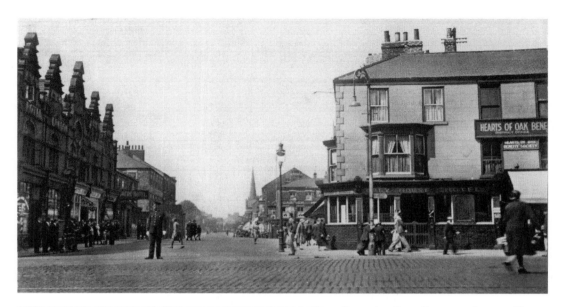

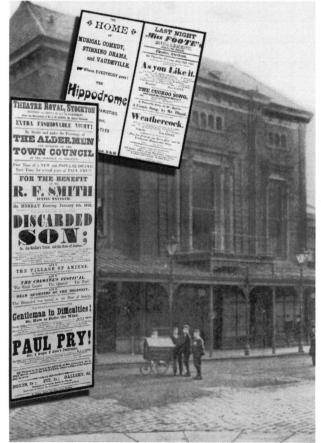

Above: A police officer stands on traffic duty in the 1920s at the junction of Yarm Lane and the High Street. The Grey Horse Hotel is on the corner, while in the distance the spire of St George's Church can be seen.

Left: The original Theatre Royal in Green Dragon Yard was opened in 1766 by Thomas Bates. It enjoyed considerable success – artistes from several London theatres appearing there. On 7 October 1833 Paganini performed to a full house, prices for a Box being doubled for the night to 38p. In 1866 it opened as The Oxford, a music hall; by 1874 it was owned by the Salvation Army; eventually it became J.F. Smith & Co.'s Nebo Confectionery factory. The New Theatre Royal, Yarm Lane, also opened in 1866 with a capacity for 1,650 people. Sir Henry Irving once played there. The theatre burned down in 1906, becoming a roller-skating rink before becoming – in the 1920s – the Maison de Danse – Jack Marwood's Band played there for over forty years. The building was finally demolished in the 1960s. The posters are from the Theatre Royal and the Hippodrome, which had opened in 1905.

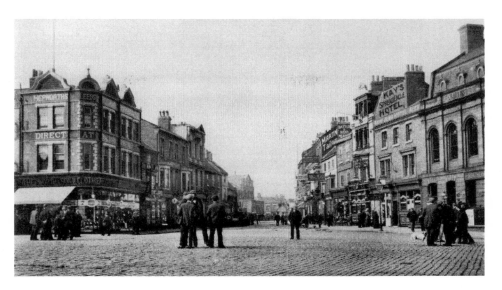

Dovecot Street was once called Ducket Lane, a name dating back to the time when it bordered ploughed narrow strips of land which stretched down to Yarm Lane. The dovecot which stood at the entrance to the street, had been converted to a house by 1639. Later called Dove Cote Lane, it was a very short street ending at West Row – in 1724 a Quaker Meeting House stood there.

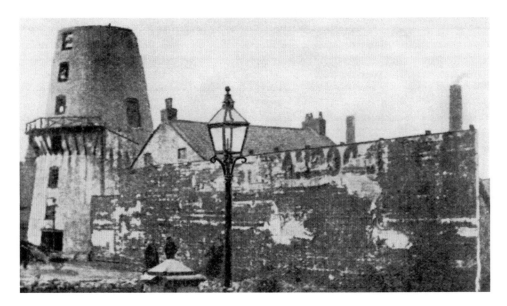

In the early nineteenth century Dovecote Street led to Windmill Lane (later Mill Lane), linking the town with Dovecot Mill (built in about 1814 and shown here in the 1920s). The mill was a tall structure of at least six storeys and features a reefing gallery. Like other mills in this area, Dovecot Mill had easy access to send or receive grain from ships berthed on the River Tees. The mill in Dovecot Street was finally demolished in the early 1930s.

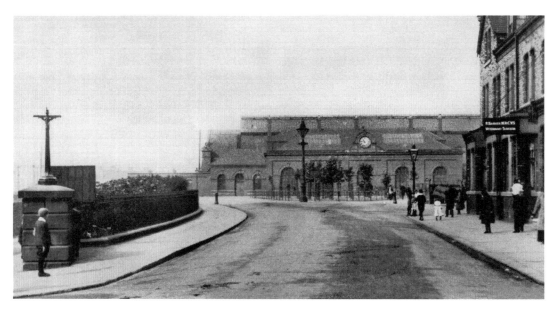

This view looks towards the forecourt of Stockton Station. The station, the second on this site, opened in 1893 with two through-platforms as well as a glass-panelled roof – it was considered to be an elegant building worthy of a town so important in commercial railway history. Now it has all been swept away, the station buildings closing in 1988. One of the best known hotels in the area, the Queen's Hotel, stood to the right of this image.

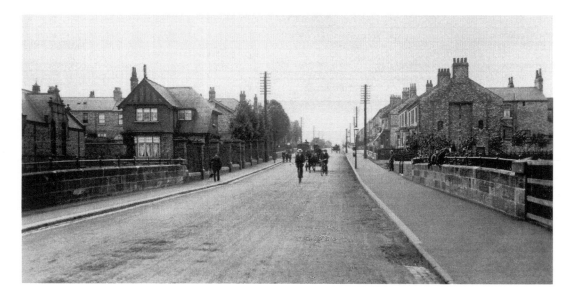

As Stockton developed westwards in the later nineteenth century, new areas of housing were needed. One major link to the town was Durham Road, shown here in about 1910. The view is taken close to the Londonderry Bridge with the entrance to Dundas Street, just visible to the right of the image. In the distance hedgerows can be seen along an undeveloped part of the road.

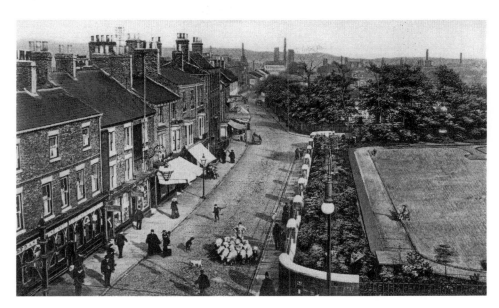

This image of Church Row from about 1904 shows aspects of the rural and industrial economy on which Stockton was so dependent at the time. In the distance, the chimneys of the Stockton Malleable Iron Works are visible. Sheep are being driven along the road towards the High Street while on the right, beyond the lawns surrounding the parish church, are the stalls of Stockton Cattle Market, then located in The Square. Beyond that is Paradise Row.

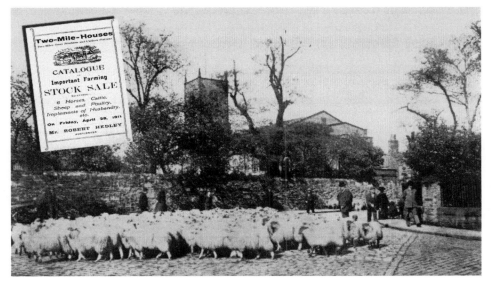

Stockton's links with agriculture 100 years ago are again illustrated here. Sheep are being herded along the cobbles around the Cattle Market to the High Street. On the left is the entrance to Thistle Green while the parish church is in the background. Today this corner lies between the police station and Stockton library. The inset is from a stock sale at Two Mile House, a local farm.

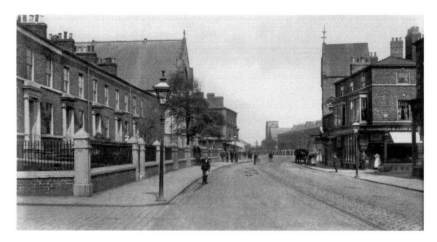

Norton Road, *c.* 1896. In the foreground on the left is Tennant Street with North Terrace, a fine row of Victorian properties up to the North Terrace Methodist Chapel built in 1866. On the right is a fruit shop on the corner of Queen Street – a school can be seen in the distance. The tower of St Mary's Roman Catholic Church, built in 1844, located on the corner of Major Street, is also visible.

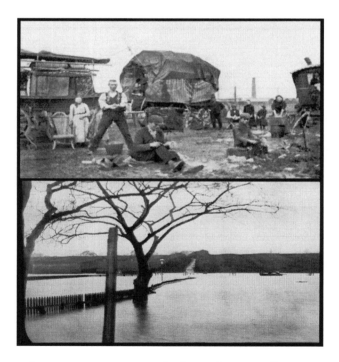

The upper image shows gypsies camping on land at Light Pipe Hall Farm on Tynedale Street, close to the Victoria football ground. Much of this area to the north of Oxbridge Lane is now developed, although at this time, (*c.*1907) it was at the edge of the town. The chimneys of the Moor Steel & Iron Works can be seen in the distance. The lower image shows flooding of the Lustrum Beck in about 1908, along the road to Norton, close to Norton Bridge.

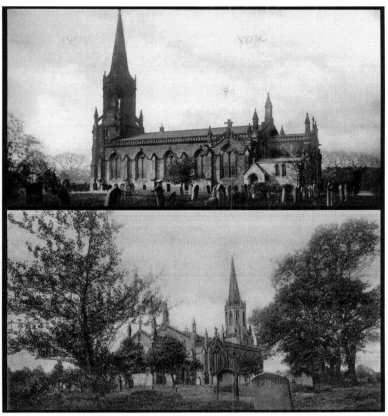

Above: This photograph shows Holy
Trinity Church. Opened on 13 May
1838, it was built on Black Lion
Farm, once part of Castle Park, on
land which had been farmed since
the Restoration. The entrance to
the farm track was reached from
Yarm Lane. In the early years there
were still haystacks and a large
pond in the vicinity of the church.
Wordsworth was said to have enjoyed
walking across this land when
staying in Stockton. These images
from about 1900 show the fine
architectural style of the building as
well as the open nature of the site.

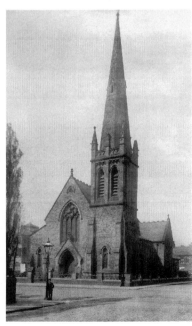

Right: St George's Presbyterian
Church in 1896, located on Yarm
Lane opposite the entrance to
Bowesfield Lane.

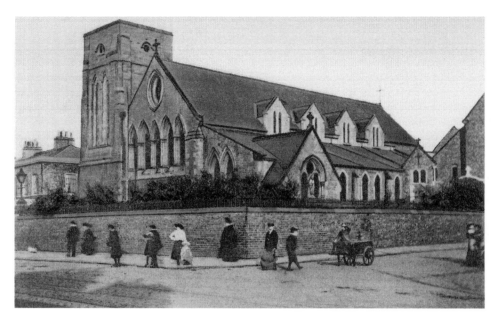

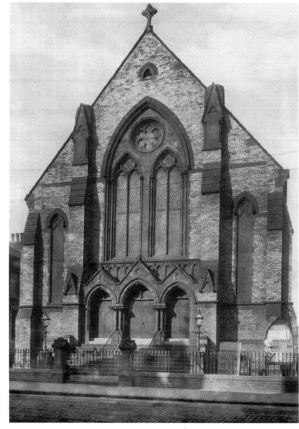

St Mary's Roman Catholic Church (built in 1844) on the corner of Major Street and Norton Road. This image is from around 1907.

The North Terrace Methodist Chapel built in 1866, located on the junction of Hume Street and Norton Road. John Wesley first visited Stockton on 10 August 1748, when he recorded in his journal that he had preached in the Market Place 'to a large and rude congregation'. Wesley made several more visits and on one occasion his preaching was badly disrupted by a Press Gang as they attempted to take two local men for a man-o'-war vessel.

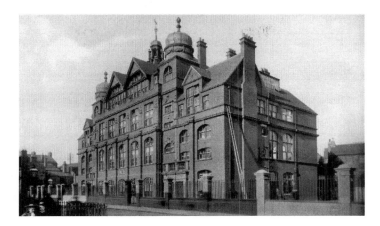

This image from about 1896 shows the newly opened Higher Grade Schools building, which stood in Nelson Terrace. The school later became Stockton Secondary Grammar School, before pupils moved to a building at Grangefield in 1951. The premises were then used by the Stockton and Billingham Technical College until 1975. After a brief use by Stockton's Further Education Department, the building was demolished in 1985.

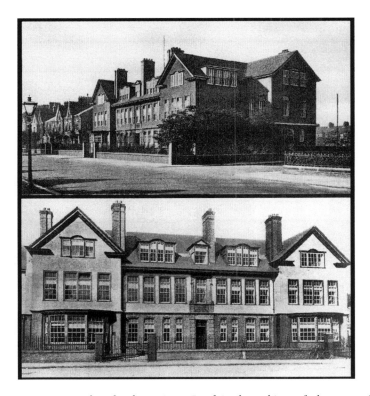

The Queen Victoria High School on Yarm Road is the subject of these two images. Opened on 28 October 1905 by Princess Henry of Battenburg, youngest daughter of Queen Victoria, the school established a fine reputation for itself before it merged with Cleveland School in 1970 to become Teesside High School in Eaglescliffe.

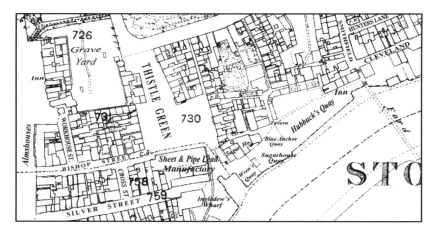

This nineteenth-century map centres on the Thistle Green area and shows many narrow streets and yards to be found in this part of the town. Conditions were often very difficult for residents who lived in these properties. Although the Ranger Report in 1850 flagged up serious concerns, it was over seventy years later before the massive clearance of the area finally began. (Reproduced with the kind permission of the Ordnance Survey)

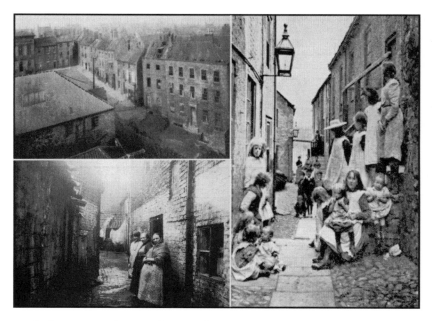

By the late 1800s, the area down to the river, east of Stockton High Street, was increasingly becoming one of squalor and misery for those living there. Thistle Green (top left) a fashionable residence in eighteenth-century Stockton was at the heart of this rapidly declining area. Constables Yard (shown below) typifies the living conditions in many yards close to Thistle Green. Mason's Court, on the right, ran from opposite the Shambles in the High Street down to the river. The group of children posing for the photographer add a poignant note to the scene.

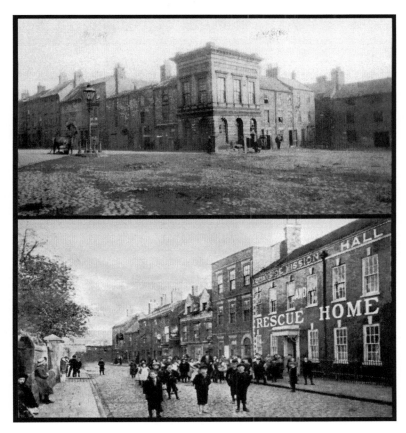

Two more images of Thistle
Green. The lower image shows
the Quayside Mission Hall
and Rescue Home, located on
the south side of The Square.
The entrance to the notorious
Housewife's Lane lies just
behind the group of children
in the foreground.

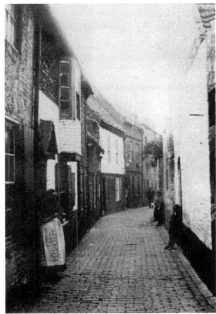

Housing was particuarly
poor in the area around
Housewife's Lane. This image
shows the entrance to the
Lane, which ran down past
the Baltic Tavern towards the
river at Hubback's Quay. The
grim, dark living conditions
are obvious for all to see.

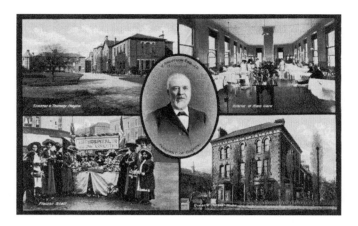

A surgical hospital had been established in Sugar House Lane in 1862 before a plot of land on Bowesfield Lane was purchased for the site of the Stockton and Thornaby Hospital, which opened in 1877. There are anecdotal tales of accident patients being wheeled in the early days through the street to reach the hospital, which was then surrounded by fields. Further development of the hospital – including a major extension in the 1920s – meant that accommodation was increased for up to 130 patients. The hospital, the Queen's Nurses Home, and a ward are shown here along with a fundraising event in the town.

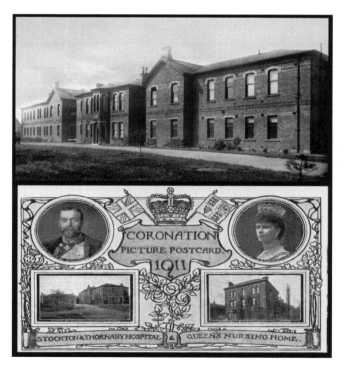

A more detailed image of the hospital in about 1896 is shown here along with a commemorative card featuring the hospital, produced to mark the coronation of George V in 1911. The main entrance and adjacent blocks are shown here. The hospital closed in 1974.

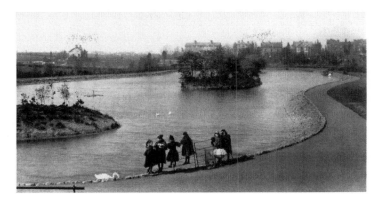

In 1890, Stockton Corporation discussed the idea of buying thirty-six acres of land on the outskirts of Stockton to be used as parkland. When it was decided not to go ahead with the scheme – because of the finance involved – Major Robert Ropner of Preston Hall offered to pay for the land and Ropner Park was subsequently opened on 4 October 1893 by the Duke and Duchess of York. This image from about 1896 shows the lake in the Park shortly after the opening. The undeveloped nature of the area can be seen along with residences in the distance situated along Oxbridge Lane – the isolated detached property is Brookside, which stood next to Oxbridge.

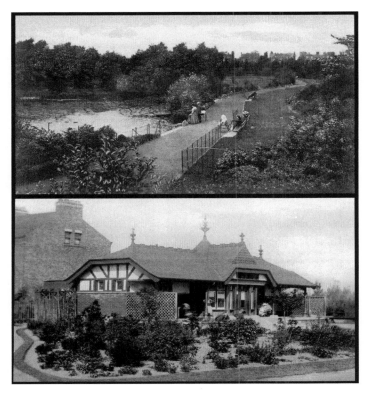

These two images are from about 1910. The top picture shows the lake surrounded by more mature vegetation. Park Lodge is shown in the lower image.

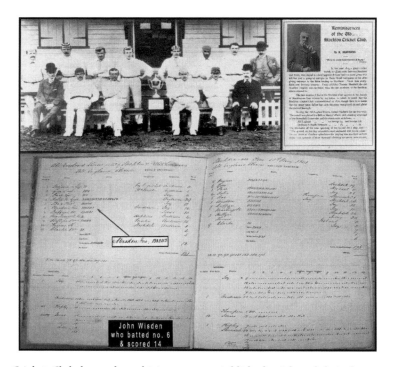

Stockton Cricket Club has a long history – an established cricket club is first recorded in 1816. Under the Presidency of Dr William Richardson in the mid-1840s, the club became one of the strongest in the area, hosting games against an All-England XI on six occasions between 1847 and 1859 – though it was only in 1858 that Stockton finally defeated the opposition. In 1851, John Wisden, later associated with the cricket almanacs, played for the All-England team, as recorded in the official score book. The Stockton team that won the Durham Cup in 1890 is shown here. The top right image is an article written by Michael Heavisides about his memories of the cricket club.

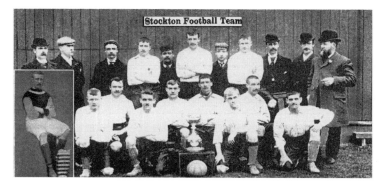

Stockton Football Club team is shown here after winning the Durham Challenge Cup in the 1894-95 season. The team, having been one of the founder members of the Northern League in 1888, were one of the strongest local teams at that time. They played many stirring games including matches in the FA Cup against teams of such calibre as West Bromwich Albion and Wolverhampton Wanderers.

In 1895 Stockton FC entered the FA Amateur Cup for the first time, being knocked out by Bishop Auckland. They reached the final in 1896, losing to Old Carthusians 4-1. In 1903, however, they won the cup, defeating Oxford City in a replay at Darlington by 1-0. The winning team is featured here.

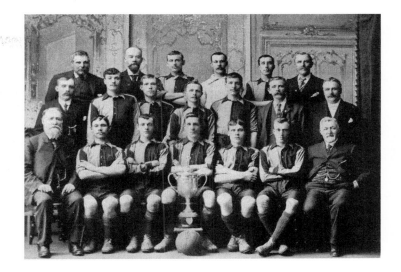

Stockton FC won the cup again in 1912, eventually defeating Eston United 1-0 in a replay at Middlesbrough's Ayresome Park ground. These images are from a rare copy of the programme for the first game between the clubs held on 13 April 1912. This was to be the final time they won the trophy.

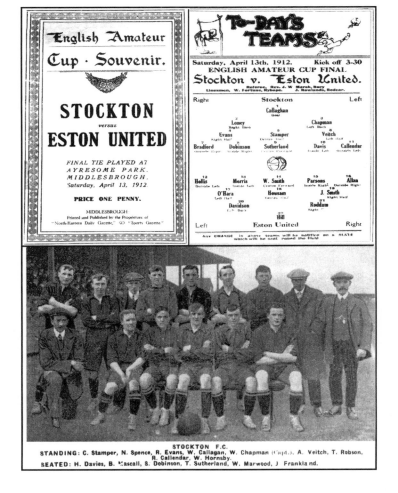

STOCKTON F.C.
STANDING: C. Stamper, N. Spence, R. Evans, W. Callagan, W. Chapman (Capt.), A. Veitch, T. Robson, R. Callendar, W. Hornsby.
SEATED: H. Davies, B. Mascall, S. Dobinson, T. Sutherland, W. Marwood, J. Frankland.

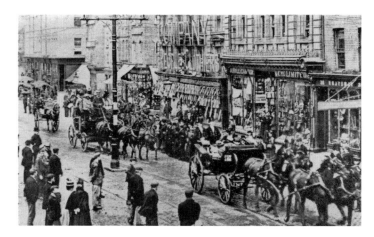

Lord Londonderry is seen here with his official party on their way from Wynyard Hall to the August meeting at Stockton races in 1910. This was a lengthy procession which attracted large crowds as it made its way down Stockton High Street, before crossing over the river at the Victoria Bridge on its way to the racecourse

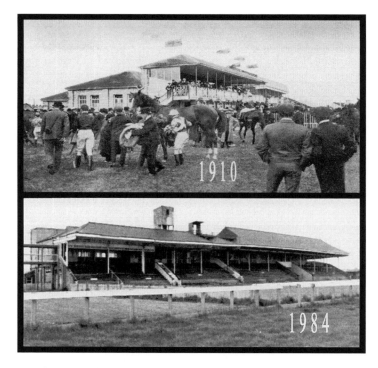

The contrasting fortunes of racing at Stockton are shown here with a race meeting from 1910 and a view from 1984, by which time the course had been sold off for commercial development. Racing at Stockton began in 1724 at Mandale Carrs (now part of the university at Stockton) and continued there until the meetings lapsed in 1816. In 1825, the meetings were revived and held at Tibbersley Farm, Billingham. In 1845, the races lapsed again only to be revived in 1855 on the course shown here at Mandale Bottoms.

Three racecards from the eighteenth and nineteenth century are featured here. Of particular significance is the card from 1831, when the race meeting was held at Tibbersley Farm Billingham. In 1797 the meeting lasted four days, from 13 September to Saturday 16 September, when the highlight was a match over two miles between Mr Jefferson's filly Lucy and Mr Heltus' bay filly Lydia, with twenty-five guineas going to the winner.

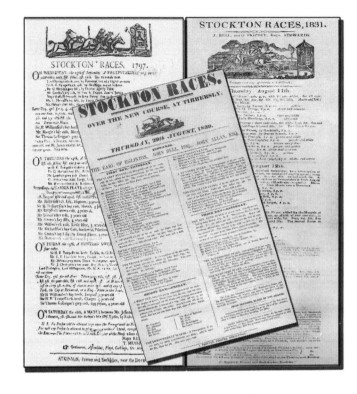

Buffalo Bill brought his Wild West show to Stockton on 7 July 1904. It created great excitement and huge crowds gathered to see the show held on Black Moor at the end of Dovecote Street, close to Light Pipe Hall Farm. Acts featured not only Colonel W.F. Cody (Buffalo Bill) himself but also other famous names such as Annie Oakley and an original rider from the Pony Express. The Cherry Fair Races at Stockton, which date back to at least the eighteenth century, were held annually on 18 July. Several photographs exist of the races, including this one dated 1904. The races were held at the Victoria Football Ground close to Oxbridge Lane and featured donkey races as well as several other fun activities.

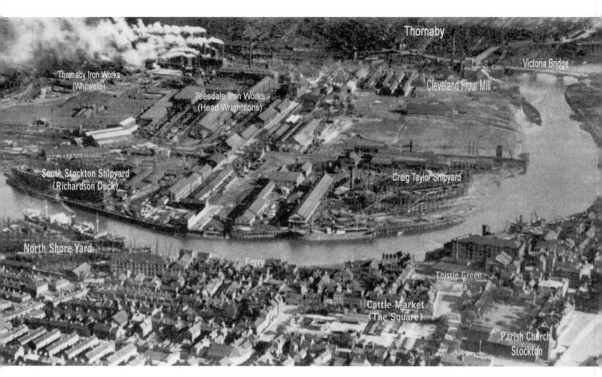

It is hard to reconcile the heavy industry in this aerial view of Stockton and Thornaby in about 1930 with the area as it is today. The ironworks and shipyards shown here employed up to 5,000 people, and names like Craig Taylors, Richardson Ducks and Whitwells – all works located here – were familiar to every household. Thistle Green, close to the lower edge of the image, was a fashionable residence in the eighteenth century, but by the 1920s it was a slum area in the process of being cleared. The northern end of the High Street close to Stockton parish church is also visible.

FIVE

SOUTH STOCKTON
AND BEYOND

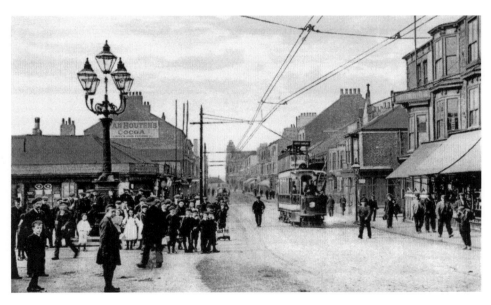

The developing of the wider area beyond Stockton absorbed old communities, creating new names or places with a very different profile. This photograph shows the Five Lamps, a unique five-lantern gas lamp, which stood at the junction of Mandale Road and George Street, shown here around 1905. The lantern was a recognised landmark in Thornaby for many years, a meeting place for speeches and rallies of religious and political groups. The original five lamps were presented to the town in 1874 by three local JP's to commemorate the extension of the boundaries of South Stockton. The original gas structure was replaced by an electric lamp with five lanterns in 1950. Thornaby Town Hall is in the distance.

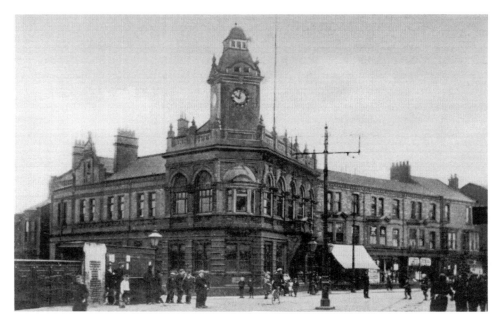

The development of Thornaby as a separate borough took place in the late nineteenth century. The original settlement, South Stockton, was created in 1838 when William Smith, owner of a pottery works just north of Thornaby village since 1825, bought 110 acres of land south of the river and sold the plots off to speculators. Other buildings were also established close to the level crossing and Stockton Bridge and the rapidly expanding community became known as South Stockton. On 6 October 1892, the Municipal Borough of Thornaby was created. The Town Hall is shown here in about 1904.

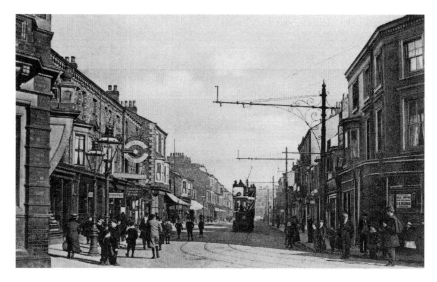

Mandale Road, looking towards the Five Lamps from outside the Town Hall. A busy thoroughfare, the road was part of the route from Stockton to Middlesbrough and was used by the electric trams.

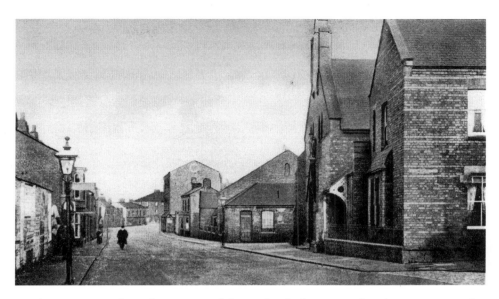

Westbury Street in Thornaby was one of the roads which converged at the Five Lamps. This image from around 1907 gives a detailed image of the terraced housing found in the area at this time. Westbury Street School and the junction with Gilmour Street are on the left while the Roman Catholic Church is in the right foreground. There were many streets like this in Thornaby at this time, with most people being employed on local heavy industry.

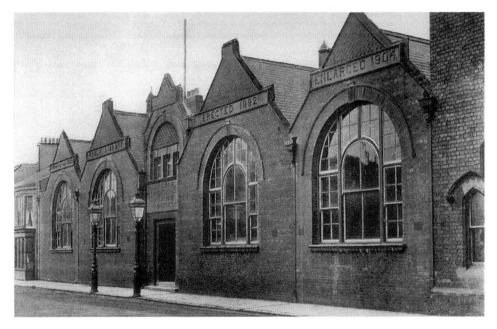

The Public Library in George Street, shown here in about 1906 opened on 8 June 1892 after an initial suggestion from Alderman Thomas Wrightson JP. It quickly became very popular with residents and in 1904 a Children's Library was added after a grant of £1,500 was received from the Andrew Carnegie Foundation.

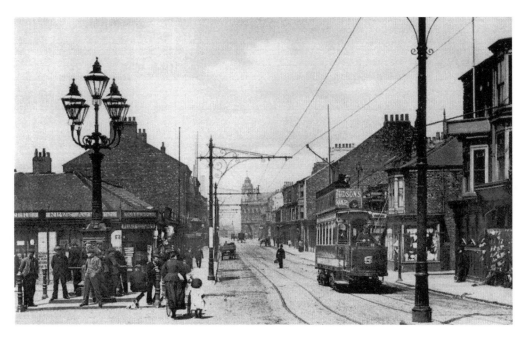

The original Five Lamps were presented to the town in 1874 by three local JP's to commemorate the extension of the boundaries of South Stockton. The original gas structure was replaced by an electric lamp with five lanterns in 1950. Thornaby Town Hall is in the distance.

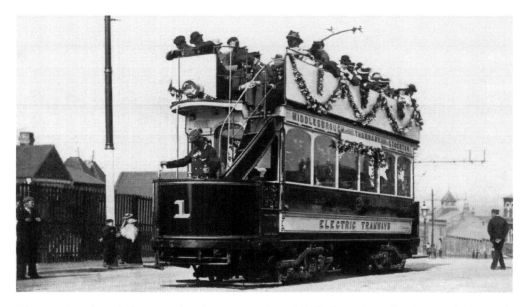

The opening day of the new electric tramway from Middlesbrough to Stockton and Norton is being celebrated by this, the first electric tram to arrive in Thornaby – seen here arriving at the top of Brewery Bank. Note the decorations along the upper deck of the tram and the severe incline of the hill it has just climbed.

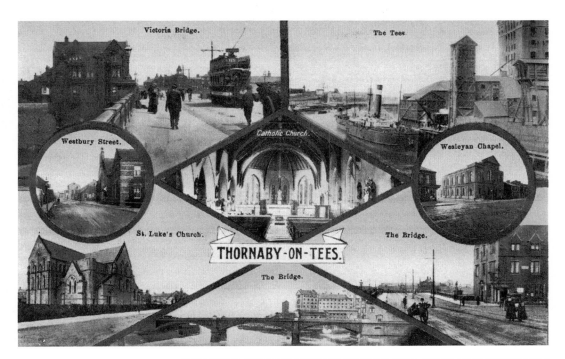

A collection of views of Thornaby in the early 1900s. By 1856, a turnpike road had been opened, creating an important link to Middlesbrough.

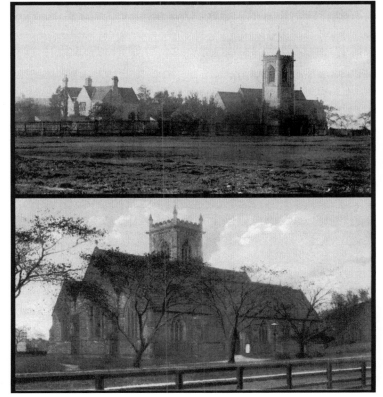

As the population of South Stockton grew, it was felt that a new church was required to meet the spiritual needs of the population. The Church of St Paul – shown in these two images – opened in 1858.

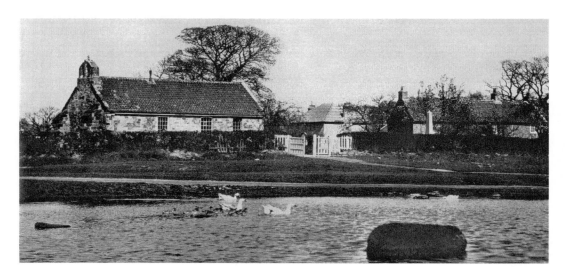

The old village of Thornaby was a small settlement centred on the village green. The Church of St Peter ad Vincula, which stood at the north perimeter of the Green, was eleventh century in origin. It was originally dedicated to St Mary Magdalene but having fallen into disuse in 1858, when the Church of St Paul opened, the church was re-dedicated when the old church was restored in 1908. The cemetery on the Green remained in use until 1869, when overcrowding led to a replacement being opened on Acklam Road in 1870. Grace Pace, mother of Captain James Cook, was raised in the old village of Thornaby. She married Cook's father (also James Cook) on 10 October 1725 in the parish church in Stainton, as the old church in Thornaby had no parochial rights and was unable to be used for marriages or baptisms.

In the 1920s, plots of land from the Thornaby Estate were offered at auction for residential development, part of the expansion southwards from South Stockton. The lower image shows Thornaby Hall, located on Thornaby Road, south of the junction with Nill Bank Lane. The Hall was reached by a tree-lined entrance from the road. On 21 September 1929, Wright, Anderson and Co., constructural engineers, announced that work would soon begin on the new aerodrome at Thornaby. The final owner of the Hall was the widow of Alderman J. Crostwaite.

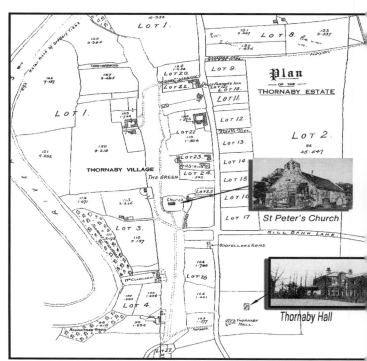

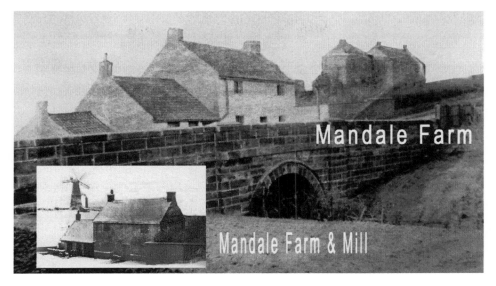

Mandale Farm

Mandale Farm & Mill

Two cuts were made to the Tees to isolate the Portrack and Mandale loops and thus shorten the distance by river to Stockton. When the cut at Mandale opened on 18 September 1810, it diverted the river but left Mandale without direct access to the river and the ships that used it. Lord Harewood received £2,000 compensation for this loss of trade.

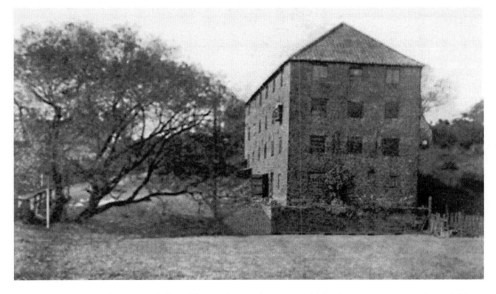

The granaries used at Mandale Mill are shown here in 1912 almost a century later. When a further cut to the river was made at Portrack in 1830, the course of the Tees had completely altered and in just two decades the landscape had changed forever. This was true in administration terms too, as the Mandale loop was now part of the North Riding of Yorkshire, rather than being the boundary with Durham.

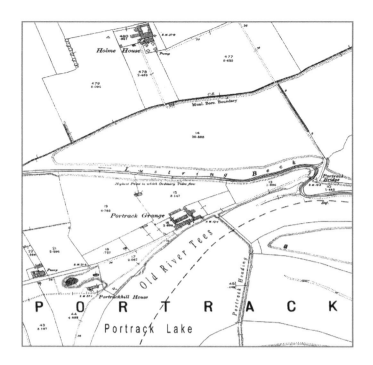

Before 1830, the Tees flowed close by Portrack and the already mentioned navigation problems meant ships were often 'racked' (or towed) by either boats, men or horses to Stockton. Other ships would unload cargoes at Portrack to be taken by smaller ships or across land to Stockton. When the Lodge of Philanthropy, a Freemason's Lodge, moved to Portrack from London in 1756, the furniture was brought by boat and landed at Portrack. Reproduced with kind permission of the Ordance Survey.

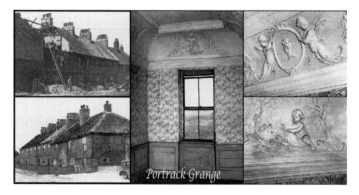

Among the buildings at Portrack were these cottages at Portrack Grange Farm, shown here on 7 May 1938. Once part of a nunnery, they contained some very fine plasterwork. An ivy-clad turret in the garden had been a watchtower overlooking the Tees. Smuggling was also thought to have gone on locally, with contraband stashed at nearby Holm House Farm. The second cut to the Tees in 1830 meant ships no longer sailed up to Portrack and its maritime connections ended. The buildings have now gone – but the name of Portrack lives on.

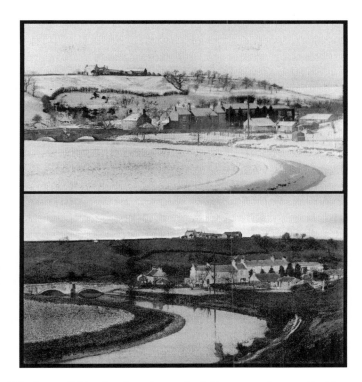

Like Egglescliffe, Leven Bridge has largely survived the many changes that have taken place around it. These views from about 1910 show the river and the Cross Keys Inn with Mount Leven Farm perched high on the hill above the river – still a familiar view a century later. The distant hilltops are part of the land farmed by Ingleby Hill Farm – today they mark the perimeter of the Ingleby Barwick housing development.

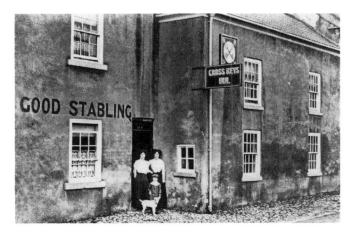

Many readers will remember the Cross Keys public house, one of several buildings at Leven Bridge. These images from about 1910 show the Cross Keys as seen from the foot of Leven Bank, with the landlady and her family standing outside.

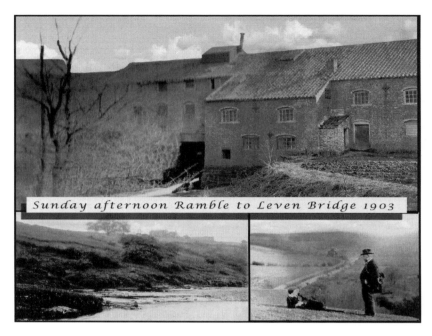

Sunday afternoon Ramble to Leven Bridge 1903

The upper image shows Leven Mill, which operated for many years close to Leven Bridge. The image lower left is the view looking west from Leven Bridge, while the adjacent image is looking down on the bridge from the hillside that lies to the north of Leven Bank.

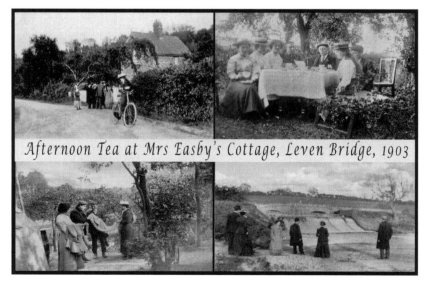

Afternoon Tea at Mrs Easby's Cottage, Leven Bridge, 1903

Rambling and other outdoor leisure pursuits became very popular in the early 1900s, and Leven Bridge was a popular destination for both walkers and cyclists, particularly on a Sunday afternoon in the summer. One resident, Mrs Easby, made teas at her cottage and this group of people can be seen over 100 years ago arriving at the cottage and enjoying tea, clearing away and then enjoying their view of the waterfalls at Leven Bridge.

These three images show the road from
Yarm going over Leven Bridge, passing
the cottages there and then taking a
sharp bend as it ascends Leven Bank.
The road was modified in April 1928,
the old narrow lane being replaced by a
wider modern road.

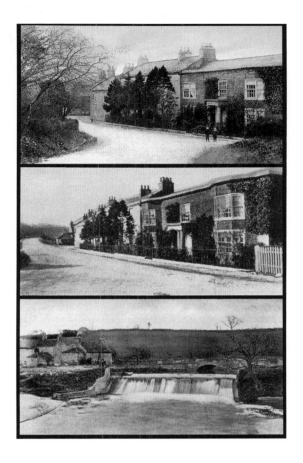

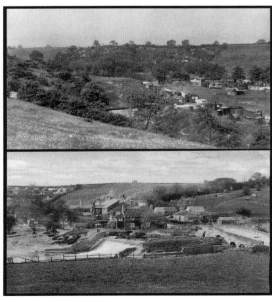

A number of holiday chalets erected
along the riverbank at Leven Bridge
provided accommodation for local
holidaymakers during the 1920s and
'30s as it became a popular destination
for families from local towns. Many
families came here each year and
remnants of the old chalets can still be
found along the riverbank.

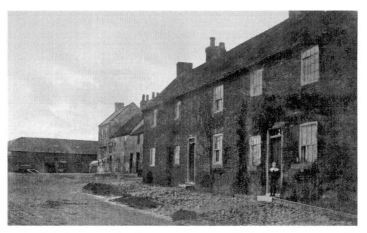

The Fox Covert public house and adjacent cottages at High Leven are seen here in 1907,
when it was known as the New Inn. The landlord was also a farmer and the farm buildings
can be seen stretching across what is today part of the pub's main car park.

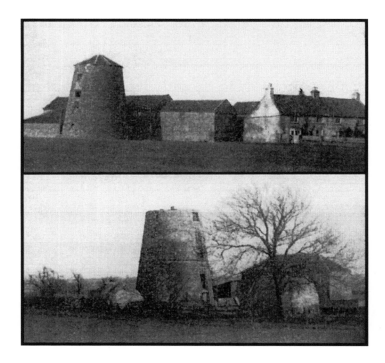

These two mills at Sober Hall and High Leven in Ingleby Barwick are shown here on 12
February 1930, when they were already in a state of disuse. High Leven was seven storeys high
while next to the mill at Sober Hall was a large granary. The date of construction for both mills
is unknown. Harrison suggests that they were possibly built to exploit the needs of Stockton and
possibly the new industrial town of South Stockton (Thornaby). He also suggests that they may
have failed in the face of competition from newer steam mills in South Stockton. Both are still
standing today despite being part of a large-scale housing development.

This image, dated 1984, was taken close to High Leven Mill and looks north up Barwick Lane. The whole development at Ingleby Barwick has been a modern-day phenomena of enormous proportions, with thousands of new homes being created on open farmland in little over two decades, changing the landscape forever.

Also taken in the winter of 1984, this view looks south down Barwick Lane, towards High Leven and the Fox Covert public house. Comparing these images with the scene today demonstrates how rapidly change can occur as residential development has since transformed this once rural area.

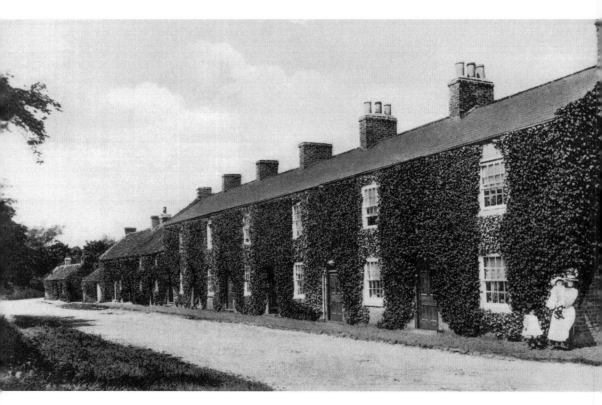

These ivy-covered cottages are in Hilton, and in contrast to the developments at Ingleby Barwick, the view demonstrates how unchanged physically some communities are, as this view remains largely similar today.

SIX

EGGLESCLIFFE AND YARM

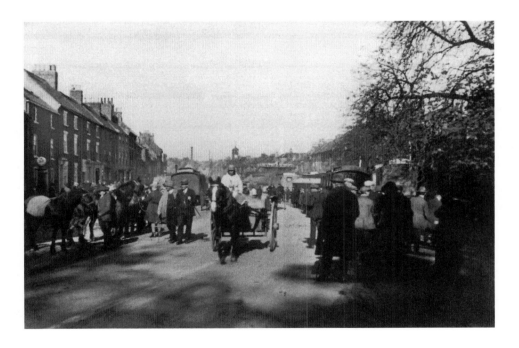

A thriving port, Yarm was for many centuries a regional economic centre before being usurped by Stockton. Eaglescliffe was a nineteenth-century development, while nearby Egglescliffe remained unchanged across the centuries. Ralph Jackson writes of his visits to Yarm Fair in the mid-eighteenth century. By the mid-1800s, it was one of the largest agricultural events in the north of England and as such brought a great deal of trade into a town which, for many years, had been a focal point for routes from all directions owing to it being the lowest bridging point across the Tees.

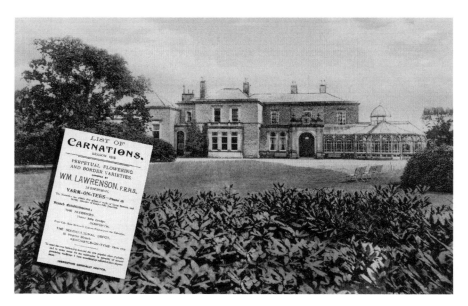

Preston Hall, seen here in about 1908, was completed in 1825 and belonged to the Fowler family. With its wonderful position on the banks of the Tees and commanding view of the hills it was a desirable residence. Preston Hall became the property of local shipbuilder Robert Ropner in 1882 and subsequently, in 1953, it was opened as a museum under the ownership of Stockton Borough Council. Part of the original trackbed for the Stockton and Darlington Railway is located in the grounds of the Hall. The inset is a front page from the 1913 Flower Catalogue of local nurseryman William Lawrenson.

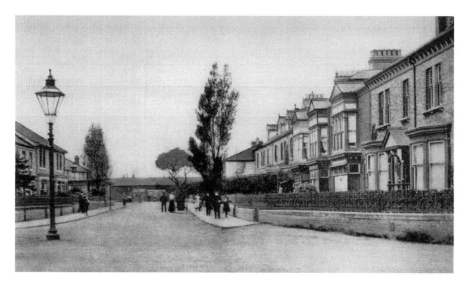

In contrast to the ancient medieval village of Egglescliffe, Eaglescliffe was a residential development established in the Victorian era. A number of large residential properties were built in the area, the start of Eaglescliffe. Station Road, seen here, has remained almost unchanged in the century since this photograph was taken.

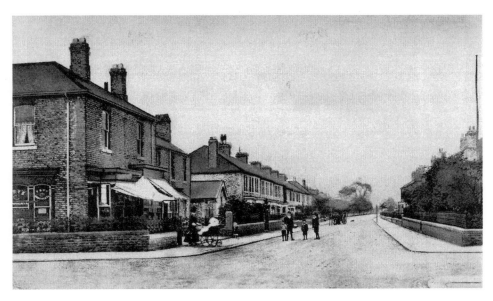

Development was closely tied to the new railway from Leeds, which opened in 1853, joining the old Stockton and Darlington line close to Whiteley Springs Farm and a newly opened station, Eaglescliffe Junction. The settlement was slow to develop, with most properties being built around The Avenue, belonging to wealthy businessmen and industrialists from local towns like Stockton and Middlesbrough. More rapid expansion occurred in the early 1900s with a number of roads such as Swinburm Road, seen here around 1908, being built.

The Primitive Methodist Chapel in Eaglescliffe, *c.* 1900.

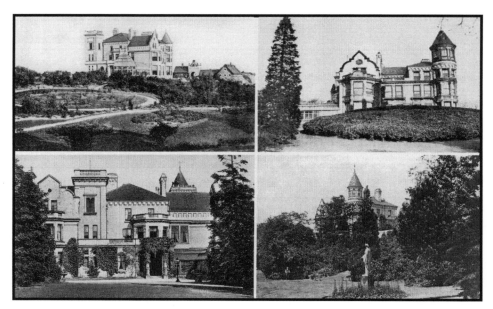

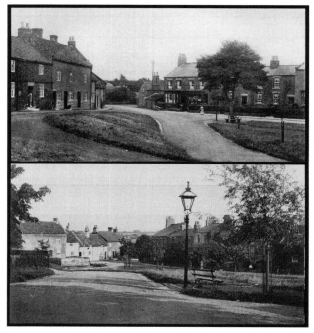

Four views of Woodside Hall, Eaglescliffe are shown here – all are from the early 1900s except for the upper right from 1934. Woodside Hall built in 1876 by Richard Appleton, from Stockton was a very striking building with four storeys commanding an excellent view over the surrounding countryside, including the River Tees flowing towards Yarm. A conservatory overlooked extensive grounds, with lawns, exotic plants, trees, statues, fountains and other water features. Sir John Harrison, Bart, five times Mayor of Stockton, later bought the Hall, before donating it to Stockton Borough Council in 1935 to be used as a maternity home. This never came to fruition; during the war it was used by I.C.I., and in 1945 it became part of Cleveland School. The formation of Teesside High School in 1970 led to Woodside Hall being demolished. Only the entrance towers and some aspects of the grounds survive.

Beyond the memory of most of today's residents is the village shop that stood in the north-east corner of the Green at Egglescliffe. The shop (Pear Tree House) is seen here in the early years of the twentieth century. Close by was a 'boot-maker', who at one time employed several apprentices. In the lower image can be seen the remains of the cow byre which once stood on the Green.

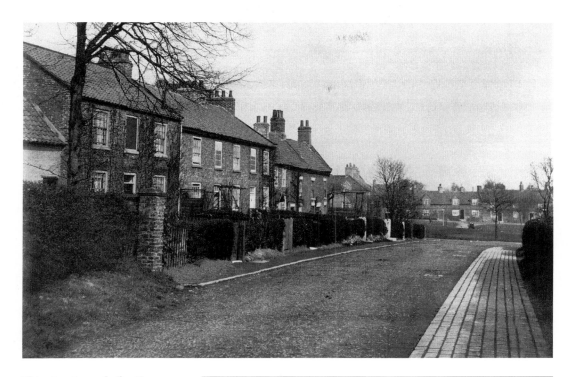

This view towards the Green bears a strong resemblance to that of today. Many residences, however, no longer house local farm workers but commuters employed elsewhere, who choose to live in Egglescliffe, now a fashionable village to live in.

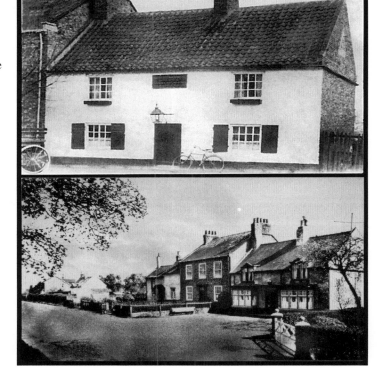

The Pot and Glass public house in Egglescliffe is shown here in about 1908 (upper image) and in the 1920s when a post office was located next door. The Pot and Glass features in trade directories from the early 1800s.

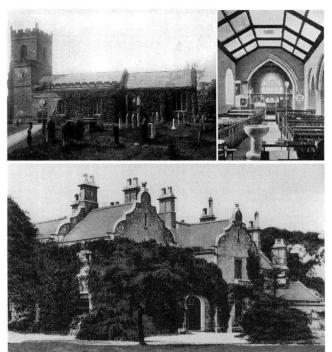

Left: The church at Egglescliffe is built on the site of an earlier Saxon building and with its commanding position over the local area it has been a landmark for many years. Many features of the church offer clues to its age, including a stone effigy thought to be of Sir Thomas de Aslackby, a knight who died in 1291. The interior of the church is shown here around 1906, while below is an image of Egglescliffe Rectory, once a three-storey building but reduced to two in 1845 during rebuilding by Rector Maltby.

Below: Stoney Bank (named after the cobbles once used to surface it) was once far steeper than shown in this image from a hundred years ago, as it went straight down in a curving line to Yarm Bridge. It was straightened in the late eighteenth century and a cutting made through the highest part of the route to reduce the gradient. The tower of the church at Egglescliffe is in the distance. A skirmish in the Civil War is said to have taken place in this area in February 1644.

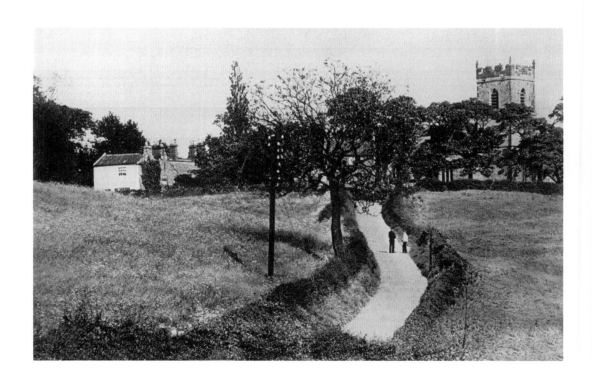

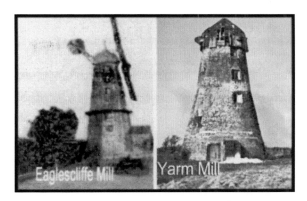

Very few images exist of the two mills featured here. Eaglescliffe Corn Mill, seen here 20 February 1929, was located on the road to Darlington at Eaglescliffe Grange Farm. Similar in design to other local mills, it was a tall structure with ogee cap roof and a reefing gallery and was said to be the last windmill in the district to manufacture stone flour. The tower windmill at Yarm was said to be one of the larger windmills in the area. The mill is shown here in a state of partial disrepair on 24 February 1931, when it was stated as being the 'last of the three old mills at Yarm, over 100 years old, and still standing'. There were three mills in the district, one at Eaglescliffe Grange, another on the site of the Millfield Estate in Eaglescliffe and this one in Yarm, situated on the riverbank south-west of the town.

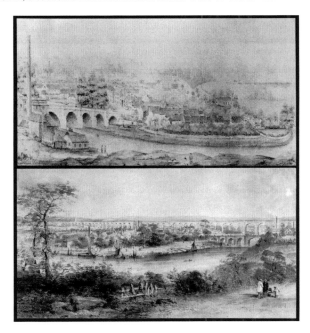

These rather antiquated images from the nineteenth century show Yarm before the viaduct was built and shortly after it was completed. One of the largest in England, the viaduct, which carried the railway line from Leeds to Stockton, was designed by Thomas Grainger. With forty-three arches, it spans half a mile and originally cost £44,500 and nearly 160 years later still stands, a tribute to the men who were involved in its construction. Note that Yarm Mill is visible to the south of the town in both of the images.

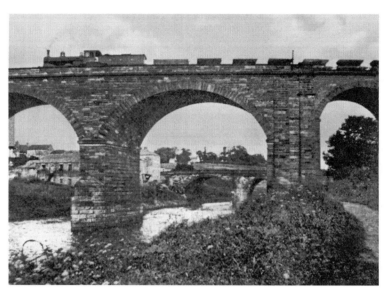

This image from about 1916, looks towards the viaduct from the west, where a passenger train travels towards Yarm station. Through the arches can be seen the buildings of Cecil Wren's Vinegar Brewery, which opened in 1904. A paper mill once stood on the site, having opened in 1832; the mill had once employed up to forty people. Cecil Wren, who lived in West Street in Yarm, worked at the brewery all his life. After he died the site was sold and the buildings demolished in 1973, as part of a road improvement scheme.

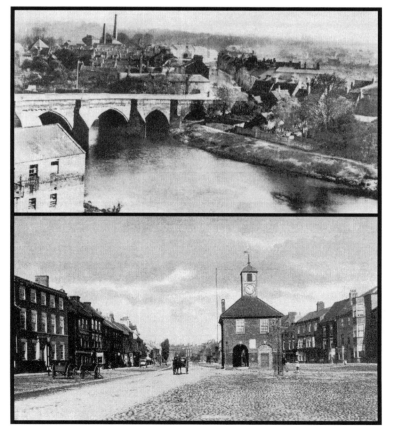

Yarm is seen here from the north around 1910 (top) with the Tees and Yarm Bridge visible in the foreground. In the distance is the High Street and to the left the chimneys of the old Tannery. Wrens factory is visible in the left foreground. The town was once a prominent commercial trading centre, but by the time this image was taken port activities were considerably reduced. The lower view is Yarm Town Hall in about 1907. An impressive Dutch-style structure built in 1710, it reflects the economic confidence of the time when Yarm was still able to compete commercially with Stockton. By 1907, commercial activity had declined. The wide cobbled street and distant viaduct are of interest here, as is the fact that the memorial cross next to the Town Hall has yet to be erected.

Agreement to go ahead with the Stockton and Darlington Railway was taken at a meeting held on 12 February 1820 at the Green Dragon Hotel in Yarm High Street, and Thomas Meynell, who lived at The Friarage, was one of the leading promoters of the scheme. At the northern end of the viaduct was Yarm station, shown here in about 1908. With its lofty site it offered spectacular views of the surrounding area, including the town itself. The first station at Yarm was on the Stockton and Darlington Railway at the level crossing, close to where Allen's West station is today.

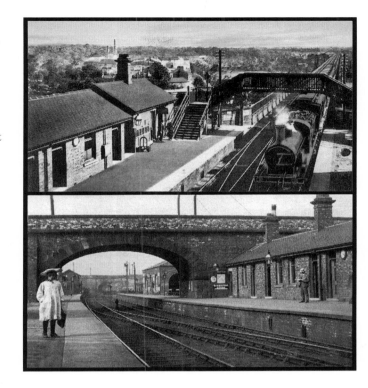

These images show Bridge House (top) in about 1908 at the entrance to Yarm High Street and a view further south (below)in about 1930. Both are still recognisable today as Yarm has managed to retain many of its architectural features, especially in the High Street area. The lower image shows the Ketton Ox public house, one of the oldest in the town. On the same side of the High Street is the house which was once The Dragoon Inn, run by Thomas Brown, distinguished for his deeds in the Battle of Dettingen on 27 June 1743. Brown was knighted, eventually returning to Yarm to run the inn.

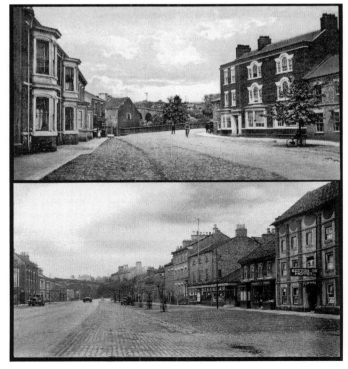

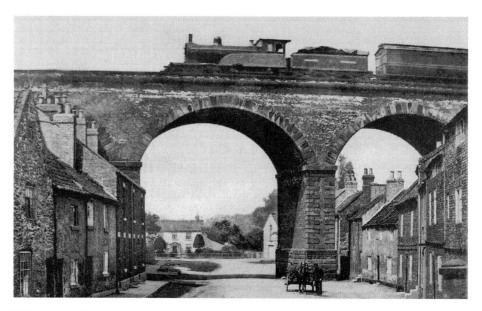

This spectacular view of a train travelling south on the viaduct as it crosses Bridge Street shows the proximity of the houses which lie underneath. Anecdotal evidence records the lively impact on the town from the influx of labourers and navvies during the period of construction, as well as local men only too pleased to have the opportunity to earn the good wages that were being paid. Only a single horse uses the road, a far cry from the busy route it is today. Further down in West Street, construction of the railway meant that Hope House was actually reduced in size to accommodate the viaduct.

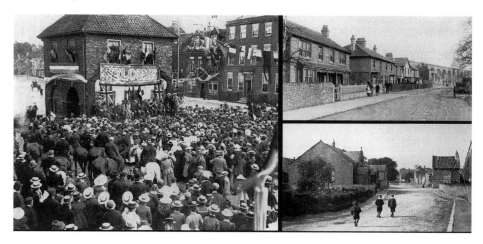

A 'Welcome Home' ceremony at Yarm Town Hall in 1902 for soldiers arriving back from the Boer War. Eastry House is in the background, one of several large properties on the High Street now used for commercial rather than residential purposes. The other images are of West Street; the upper image looks south along the line of the viaduct to Hope House, one of the oldest properties in Yarm. The image below shows the Primitive Methodist Church, which opened in 1897. Hope House is opposite – note the sails of Eaglescliffe Mill in the distance beyond the houses.

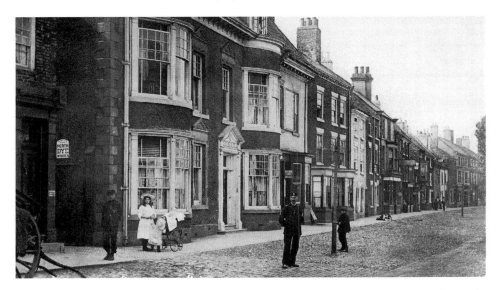

A single policeman stands outside Manor House in the High Street, *c.* 1909. Wilson and Vasey's, a drapery shop, occupied the premises before they were purchased by John Robert Clapham, one of Yarm's chief benefactors in the twentieth century. Clapham, whose father had been a grocery merchant in the town, was involved in much public work in the town. In 1925 he and his son Harvey jointly bought the Manorial rights and the Town Hall, and presented them to the Parish Council.

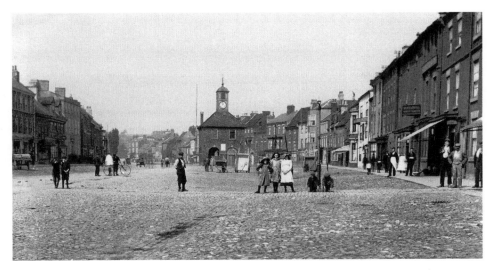

A group of children play on the cobbles in Yarm High Street in about 1906, a tranquil scene far removed from that of Yarm today. The Town Hall, which was built in 1710 by the Lord of the Manor, the third Viscount Fauconberg, dominates the scene. Originally used as a courthouse as well as a market, local magistrates sat every two weeks; the steward of the Lord of the Manor also used it for rent audits. To the right are the Black Bull and Green Tree inns. John Wesley visited Yarm nineteen times between 1748 and 1788, staying with George Merryweather at No. 17 High Street.

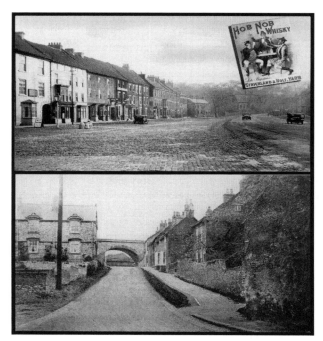

This view, looks south down Yarm High Street, in about 1932. Even though the car has obviously arrived, the town still retains its quiet tranquillity. The Black Bull and Green Tree inns are on the left while in the distance is the Catholic Church of St Mary and St Romauld – built in 1860 in the grounds of the Friarage by Thomas Meynell. Opposite is the entrance to Bentley Wynd (lower image) around 1910, with one of the arches from the viaduct visible in the background.

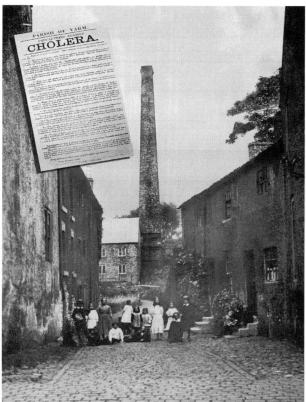

A group of children pose in Atlas Wynd, one of many yards and passageways between the High Street and the river. The skyline is dominated by the chimney at H. & J.C. Hird's riverside skinyard and tannery, which opened in Yarm in 1860. The inset is from a handbill highlighting about precautions necessary to guard against cholera, including the need to lead a regular and sober life and for a propitious use of chloride of lime on walls as well as using it diluted with water to remove infection from clothing.

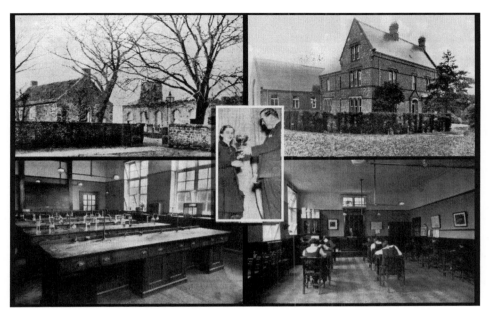

The original Yarm Grammar School was founded in 1590 and was located south of the church in the churchyard (see image top left). A new building (top right) was opened on 5 March 1884 on a site west of the Spital. When North Riding County Council took over the school in 1913 the site was extended, as it was again in 1935. The lower images show the Science Laboratory and a class being taught in the Assembly Hall. The inset is Speech Day on 8 December 1934 and the presentation to Miss Armstrong of the Chaloner House Cup by the Earl of Feversham. The school buildings are now part of Yarm School.

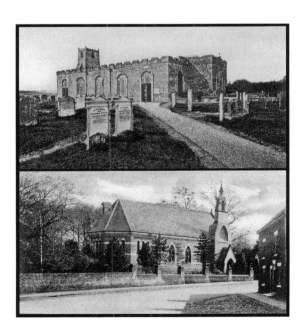

The upper image shows the parish church of St Mary Magdalene in about 1908, rebuilt in 1730 after a fire in 1728 severely damaged the original twelfth-century structure. The reconstruction cost £1,772. The Catholic Church of St Mary and St Romauld is seen below, along with the walls of the Friarage. Note the houses that once stood on the opposite side of the High Street, before being demolished many years ago.

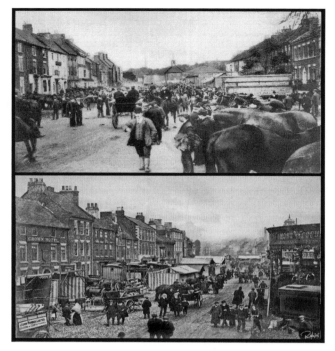

Traditionally, the first day of Yarm Fair was the horse market, followed by a cattle market and on the third day, a sheep and cheese market. It was said that almost 500 carts came to the town for the cheese fair alone, regarded as the largest in the north-east. Sales of livestock took place in the High Street until the Second World War, when, due to the increase of motor-traffic, they were removed to the cattlemart in West Street. The number of livestock sales have declined since 1945 and today only a few traditions remain, such as 'beating-of-the-bounds'. These images show the fair in 1904 and 1908 – note the Crown Hotel in the lower image, a popular haunt of farmers visiting the cattle market held at the rear of the pub. The pub closed on 4 October 1965.

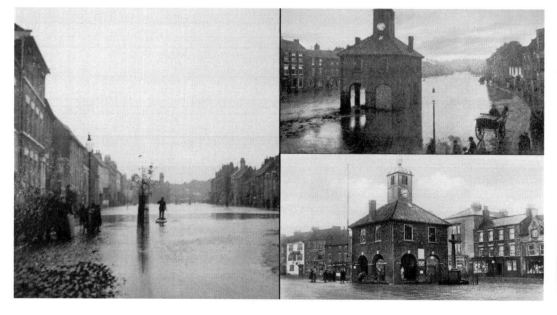

Yarm has been flooded on many occasions, as can be seen here. The floods of 1753, 1771 and 1881 respectively were particularly serious. In a diary entry for 20 November 1771, Ralph Jackson writes that he sent provisions to Yarm, which 'suffered very melancholy by the late Flood, many houses were washed in which several lives were lost; Provisions & Furniture were swept away'. The water flooded to a level of 20ft in 1771, while the flood of 1881 was said to have left a deposit of 2ft of sand and silt around the town.

These two photographs show industrial buildings along the riverside in Yarm. The top image shows a temporary bridge built across the river for Yarm Gala – a popular annual event until the First World War – up to 26,000 visitors are said to have attended one year. The Gala was held in the grounds of the Friarage at Whitsuntide. Visitors to the Gala recalled the brass band and variety acts on a stage erected in the paddock, illuminations in the nearby woods and, in the evening, dancing around the huge tree in the Friarage grounds. The lower image looks toward Hird's skinyard – note the octagonal rooftop of the Methodist chapel, which was built in 1763, and where John Wesley once preached.

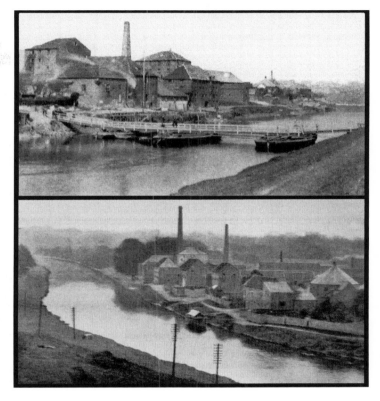

One of the most popular organisations in Yarm before the First World War was the Yarm and Egglescliffe Amateur Swimming Club. The club headquarters were based in the hut shown here and club members can be seen posing for the photograph. Many local people were taught to swim in the Tees by trainer Jack Bradley, whose name appears here on the rowing boats which belonged to the family business.

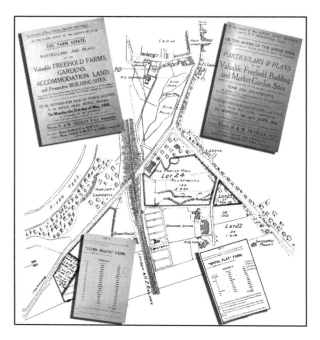

As in many other towns, areas of freehold land were being sold for development – a movement which gathered pace in the early twentieth century. In 1923, Edgar Meynell, who died unmarried, was succeeded by his sister Louisa Mary. She sold the last of the manorial rights to John and Harvey Clapham in 1925 and by 1926 she had also sold the manor lands, retaining only the Friarage and its grounds, as neither were part of the manor. These catalogues are from the Yarm Estate sales in June 1924 and May 1926. The auction of 1924 was held in the Black Bull in the High Street, while that of 1926 was held in the King's Head in Darlington. Louisa Meynell died in 1938.

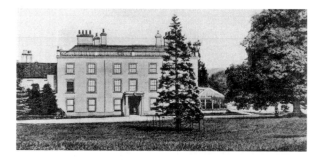

A fine building which has largely survived the ravages of twentieth-century progress is the Friarage, Yarm. It has gone from being a family home to offices to being a school. Built in 1770 by Edward Meynell on the site of a Dominican Friary (founded in 1260), it remained a family home until the mid-twentieth century (although it was occupied by tenants from 1865). The site had several outbuildings including stables, a malt-house, malt mill and brewhouse. The building was used for twenty years as offices by Head Wrightson & Co., before becoming part of Yarm School. This view shows the Friarage in about 1908, when it was occupied by Edward Whitwell. The conservatory is no longer there and internal changes have also been made to accommodate the school. Recent sensitive external development has ensured the preservation of the historic Friarage building.

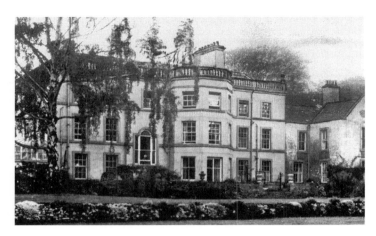

The Dominican Friary was sold in about 1553 to a Catholic, John Sayer, whose father and grandfather were buried in the nearby Black Friars cemetery. The property passed to the Mayes family in 1670 with the Friary used as a house until 1717, when it was replaced by the building of the original Friarage. This was subsequently rebuilt in 1770 after it had been inherited by Edward Meynell, when Cecily Mayes died without issue. A large expenditure was used for rebuilding, many materials being brought up the Tees by boat. The formal gardens were also laid out at this time, with large sums being spent on birch and fruit trees, bushes, garden baskets, seats and garden seeds. By 1794 there was a hot-house and in 1800 it appears the gardens were occasionally being opened to the public. Aspects of the gardens are seen here in this view from the river, c.1914.

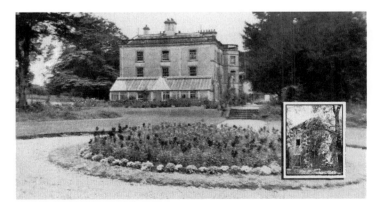

This view, taken from the south side of the Dominican Friary, shows the conservatory. Mass was carried out in secret for many years at the Friarage until 1795, when the Penal Laws had relaxed enough to allow it to be said in a room with a barrel-vaulted roof on the first floor of the Friarage, which acted as a chapel until the new church was built within the grounds of the Friarage. Today, this room serves as the library within Yarm School. Excavations undertaken in 1928 by Ralph Hudson, tenant at the Friarage, revealed the walls of a large building between the house and the church, glazed tiles, fragments of stained-glass window and some bronze tokens from the reign of Edward III. The inset photograph shows the Tudor Dovecote, recently sympathetically restored as part of a stunning riverside development at Yarm School.

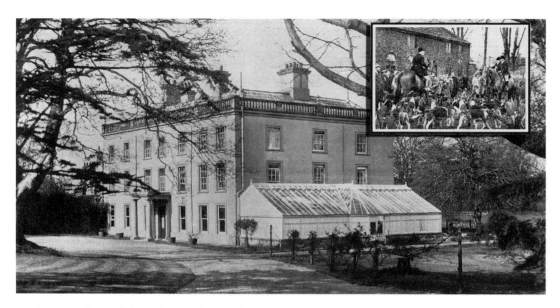

Until 1822, the road from the south passed through the grounds of the Friarage, taking a route very close to the front entrance of the building. It then passed over the Skytering Beck and into the High Street. This image shows the approximate route of the road. The road was altered between 1822 and 1825, when it was diverted along the western perimeter of the Friarage grounds, joining up with the Worsall Road, which had also been diverted to a new course south of the fishponds – once part of the Friarage grounds. The inset photograph is the Hurworth Hunt taking the stirrup cup in front of the Friarage outbuildings in January 1937.

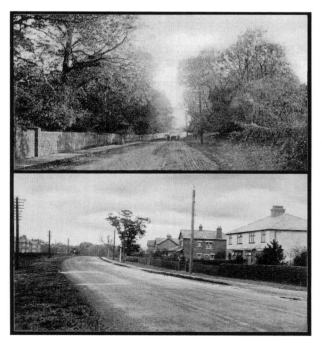

This view of the Spital in the early 1900s looks up to the junction with Leven Road and the property called Rose Hill, then part of Hedley's Garden Nursery. The wall and the woodland behind it were part of the extended grounds of the Friarage, which ran up to Little Spital Garth (on the corner of Spital Bank and Leven Road), which was part of Hedley's nursery. The lower image (*c.* 1935) is taken along Thirsk Road just south of the incline on the Spital, and shows the properties which had then been recently built along there.

SEVEN

NORTON TO HARTBURN AND LONG NEWTON

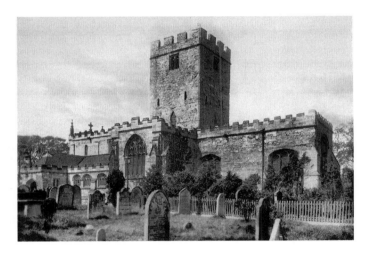

Until recent years, Norton retained much of its own identity and rural charm. Change has seen much of that eroded as urban development across to Hartburn and encircling Stockton, has occurred. Nevertheless, Norton, with its duckpond and picturesque village green, retains the air of an archetype English village. The Church of St Mary the Virgin at Norton, viewed here from the south in 1896, exemplifies that continuity through time.

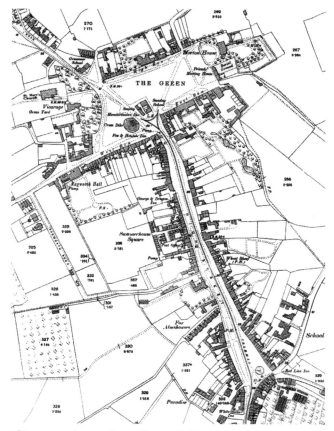

This map shows the village of Norton-on-Tees in 1897, essentially unchanged from earlier days. Although there was some sporadic development nearby, the village, with its High Street, Green and pond was still very much the focus of life in the area. (Reproduced with the kind permission of the Ordnance Survey)

Opposite above: This is Junction Road close to the turning into Station Road, *c.* 1910. It is interesting to note that it was still very much a country lane beyond the development seen here.

Opposite below: This view of Norton Duck Pond in about 1906 shows West Row, Ragworth Hall and, in the distance, Darlington Lane. The village water pump can be seen behind the old Victorian lamp standard.

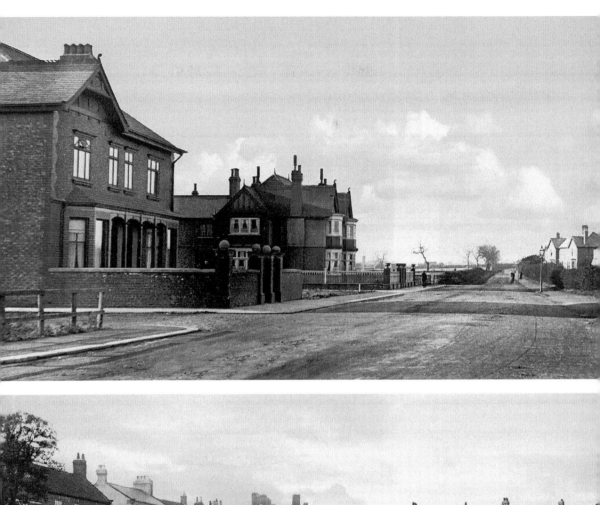

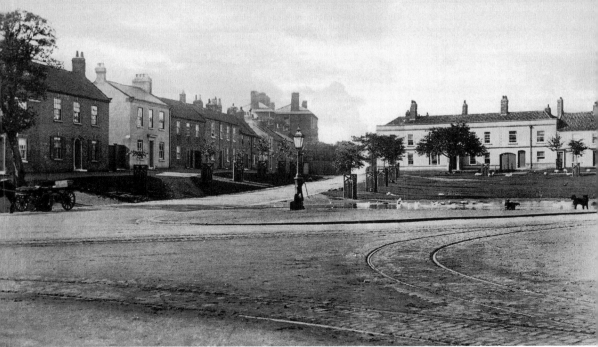

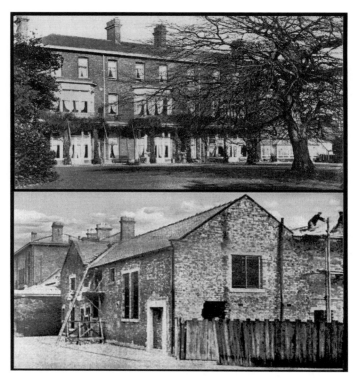

These images show Ragworth Hall, which was on Darlington Lane, on the edge of Norton village. The upper image (*c.* 1920) shows the Hall to the rear, where beautiful tree-lined gardens were well maintained. In 1926, the Hall was purchased by the Church and was later used as a private school. The lower image, dating from 23 February 1935, shows the converting of the stable and granary to a church. Despite later becoming rather dilapidated, the Hall survived until the 1960s. The area is now covered by newly built housing.

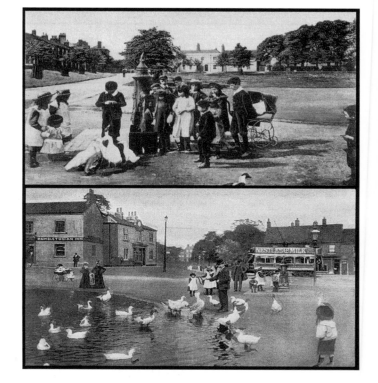

Two views of the pond from the early 1900s. The top photograph shows a group of children feeding the ducks with West Row behind, while the lower image looks in the other direction across to the Hambletonian Inn and tram terminus at the end of the High Street.

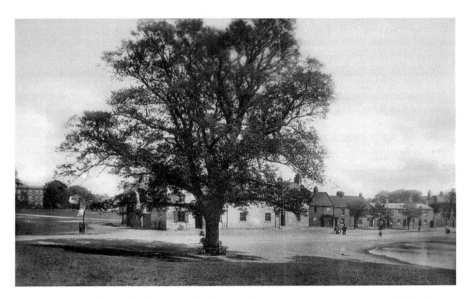

Taken on the other side of the pond, this much rarer image from about 1900 offers a slightly different perspective to the one usually seen. Part of Norton House can be seen in the distance, while in the foreground the smithy next to the Hambletonian Inn is visible.

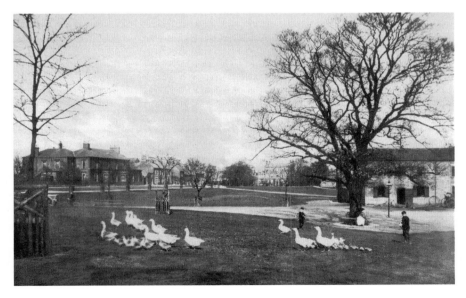

Another slightly unusual view across the Green from about 1900 again taken close to the pond but providing a clearer view of High Row, Norton House and the smith's workshop, where iron work and implements are standing outside. The large building in High Row became Red House School in 1929.

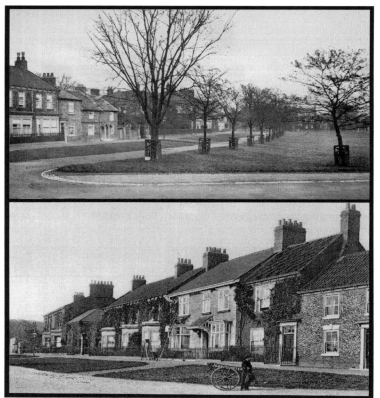

Left: Two more images of High Row in 1931 (top) and a much earlier view (*c.* 1907) looking across from a point close to Norton House.

Below: Norton House stood at the eastern end of the Green, behind a tree-lined drive. Built in 1720, the impressive, three-storey building was often used as a meeting place by the local hunt and in the early 1800s was regarded as an important house among the social elite. Byron, Shelley, Coleridge and Wordsworth all stayed here. It was demolished in the 1930s, and the inset image shows the ongoing demolition of the property on 18 April 1936.

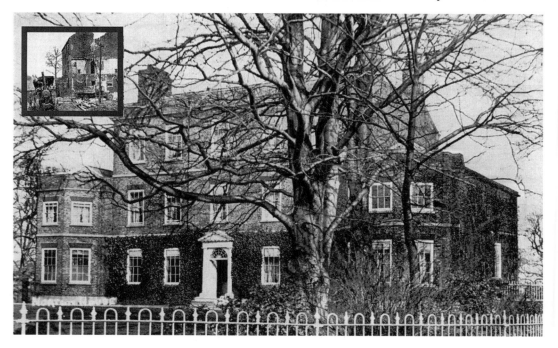

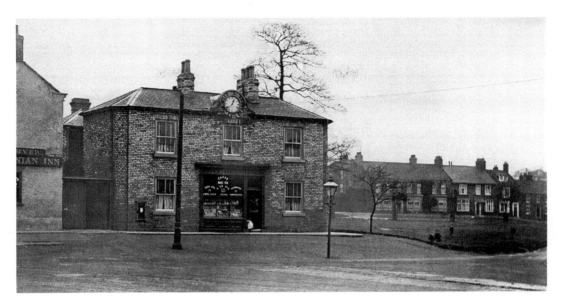

This image, from around 1900, looks on to J.M. Caskill's shop; still remembered today by older residents. On the left there is a glimpse of the Hambletonian Inn, whilst in the distance, across the Green, is High Row. The clock above the shop was a well-known landmark.

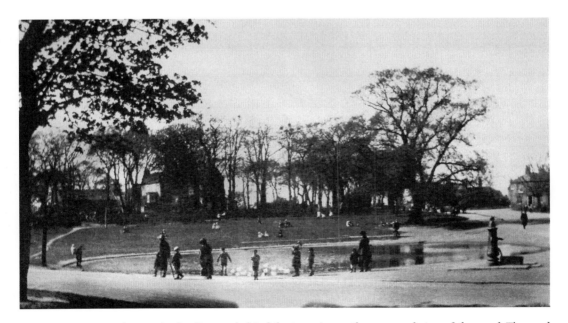

Norton vicarage can be seen in the distance behind the trees, in another unusual view of the pond. The road which went north-west from the Green passes the site of the old Grammar School at the Hermitage. Pupils attending the school paid a fee for tuition, although the vicar administered trust funds which paid for the education of six boys. It has been suggested that a tunnel existed from the Hermitage to the church, but this has never been substantiated.

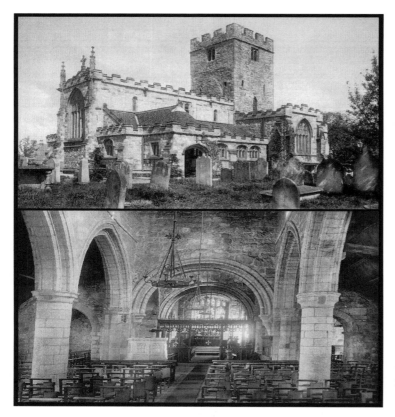

Norton (the name means 'north settlement') was an important agricultural settlement in Anglo-Saxon times – in fact, Stockton was part of the parish of Norton for many years. The village church, St Mary's, pre-Norman in origin, is opposite the Hermitage, a building dating from the eleventh century. The lower image shows the church interior *c*.1906.

A labourer tends to the plants in the garden of Norton Vicarage, described by Pevsner in 1963 as a 'stately building'.

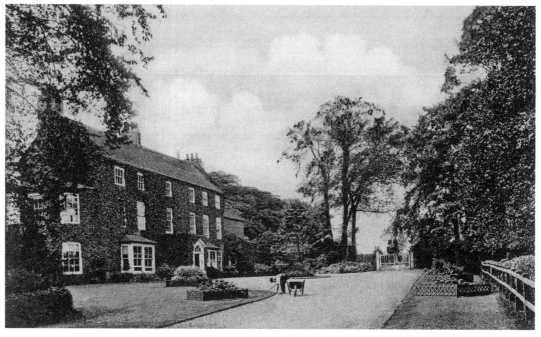

Although so many views of Norton naturally feature the pond, it is often worth looking beyond it to see other detail. In this image from about 1904, the Fox and Hounds public house can be seen at the end of East Row, while a group of men wait outside the Unicorn Inn on the High Street.

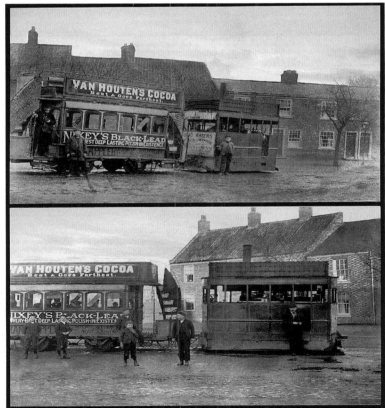

These two images show one of the steam trams which operated the route from Norton to the Harewood Arms in Thornaby. Steam trams replaced the horse trams which had served between Norton and South Stockton from 1874 to 1881. It is interesting to note the trailer which ran along with the omnibus as part of this service.

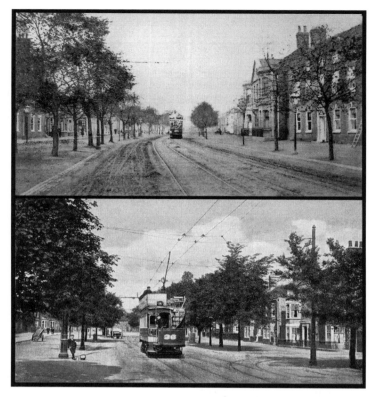

The steam trams ran until 1897, when electric trams took over the service and the route extended from Norton to North Ormesby. The upper deck of the trams, which were wide open to the elements, had wooden seats which could be turned so passengers could always face the direction in which the tram was travelling. Both images come from the early 1900s and show trams in Norton High Street. The final electric tram to serve Norton was on 31 December 1931.

An electric tram passes Blandford's Corner, named after Dr Blandford, who practised in Norton. The doctor was once summoned to attend Edward VII when he was staying with Lord Londonderry at Wynyard Hall.

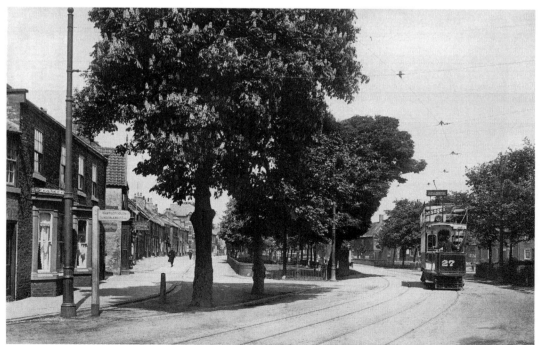

Opposite Blandford's Corner was the Diamond Jubilee Cross, which was erected in 1897 to celebrate Queen Victoria's sixty years on the throne. The premises of H. Clarke can be seen behind the cross in the lower image.

This image shows the incline on Billingham Road in about 1920. The image was taken close to the Red Lion Inn.

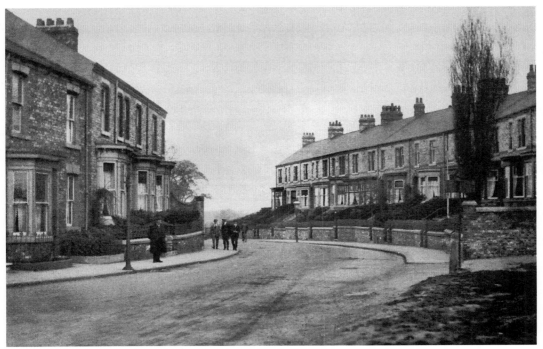

One of the largest watermills in this area was Norton Mill (mentioned in the Boldon Book in 1183) which stood on high ground west of Billingham Bottoms. An ancient pathway went across the Bottoms from the mill to Chapel Road in Billingham. These views date from the early 1900s, when both Norton and Wolviston Mills were owned by the Watson family. Like Wolviston, Norton Mill also fell into decline and by 1924 was no longer in use. Extensively damaged by a bomb in 1940, the remains of the mill disappeared under the present A19 route when it was built in the 1970s. These images show Norton Mill from the west (top left and bottom right) and from Mill Lane (top right) which linked the mill to the village. The other image shows a close up of the mill building.

A number of establishments opened to offer refreshment to the increasing number of people taking up cycling or walking as a leisure activity at the end of the nineteenth century. Norton Bungalow, which probably opened at this time, stood on the corner of Beaconsfield Road and Billingham Road. It resembled an oriental tea room and became very popular with its regular clientele. Unfortunately, the Bungalow was burnt down in 1921, an event captured in the lower right image.

In the late eighteenth century, the troubles in France which eventually led to the French Revolution created a concern in England about securing grain supplies. As a result, a number of tower windmills were built in the Cleveland area to meet this need. After the resolution of the problems in France, most of the windmills continued to be used. One of these was Mount Pleasant Mill, situated between Stockton and Norton. Its location at the end of Brown Jug Lane is shown in this map extract. The buildings of the Clarence Pottery (known for its brown earthenware) are shown to the north, where they had moved to from a site close to the Kings Arms, Billingham. (Reproduced with kind permission of the Ordnance Survey.).

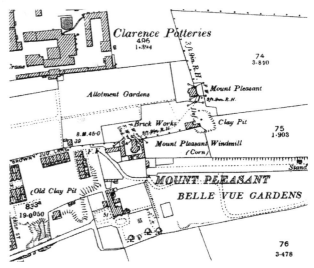

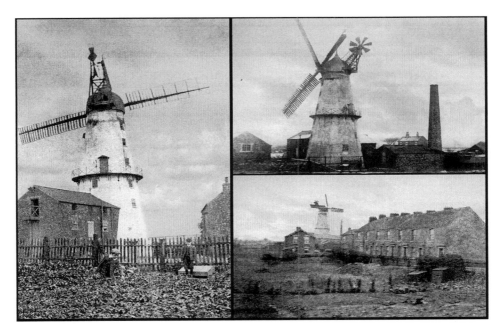

It is not known exactly when Mount Pleasant Mill between Stockton and Norton was built, but J.K. Harrison in his comprehensive book on milling suggests it was before 1824. The mill was built on high ground close to the Clarence Pottery and Mount Pleasant Farm. It was connected to the turnpike road from Stockton, and Portrack Lane which led to the River Tees and ships which berthed at Portrack. Like the mill at Greatham, this mill was very tall, with four sails and an ogee cap roof. The site later became the Belle Vue Greyhound Stadium and eventually, in the 1970s, a housing estate. All three images are from the early 1900s.

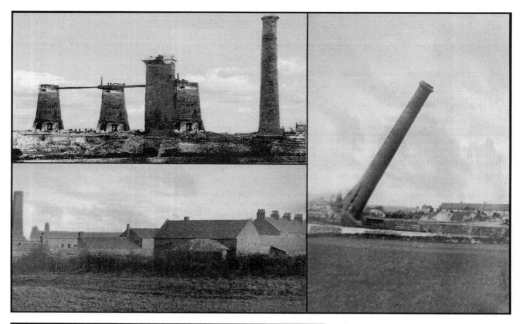

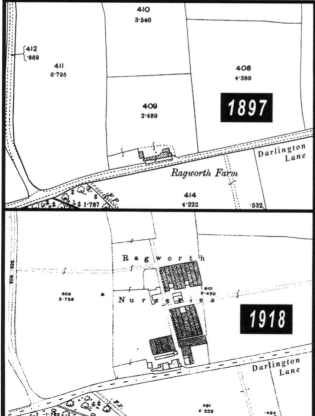

The post-1850 period was a time of great expansion for the iron industry on Teesside, with many new companies opening works here, including the Norton Iron Works of Warner, and Lucas and Barrett, located on Station Road. The site which had commenced operations in 1855 had three blast furnaces operating. The company cast the first Big Ben bell for Westminster in 1856. These images show the blast furnaces at the site and the demolition of the chimney in 1916.

Ragworth Nurseries opened on the site of Ragworth Farm in the early twentieth century. The farm was located on Darlington Lane just west of Norton village. (Reproduced with the kind permission of the Ordnance Survey)

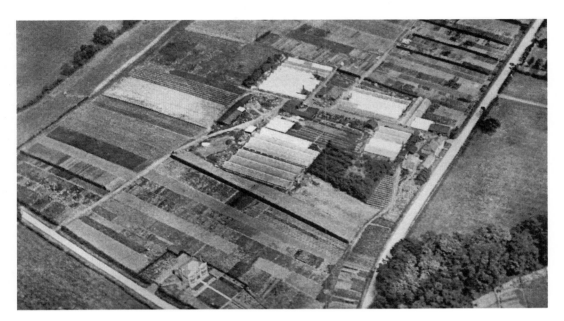

This aerial view, taken in the early 1930s, shows the extent of the nurseries at that time.

Hardwick Hall, Norton is another large house that has been demolished and replaced by a small housing estate. This image shows the Hall in its final days during the 1980s. It was constructed in the late 1870s and was located close to Harrowgate Lane. It eventually came into possession of ICI and Lord Fleck. The well known chairman of the company lived here for a period of time.

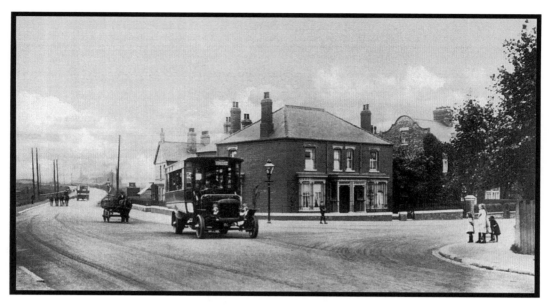

An early motorised omnibus moves along Yarm Road, passing the junction with Hartburn Lane, *c.* 1920. The chimneys at Eaglescliffe Iron Foundry can be seen in the distance.

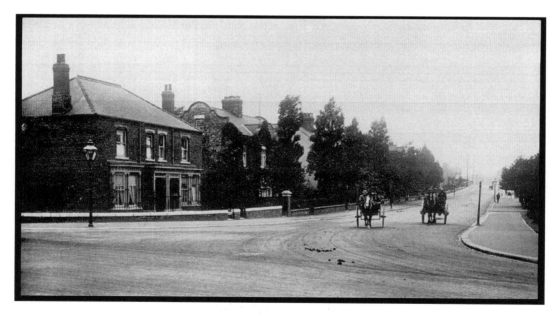

Another excellent image, taken very close to the location of the previous one, showing houses along Hartburn Lane, part of the general development of Stockton that was taking place at this time with several new residential areas being built.

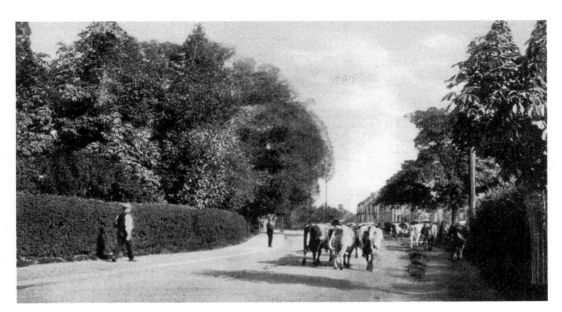

Hartburn, seen here in about 1906, was a quiet village on the road to Darlington. The cows are being walked home in the direction of the Masham Hotel, seen in the distance. Although changes have taken place in around the village, this scene has largely survived today. Many of the old buildings in the village still remain, while new building has not been too intrusive.

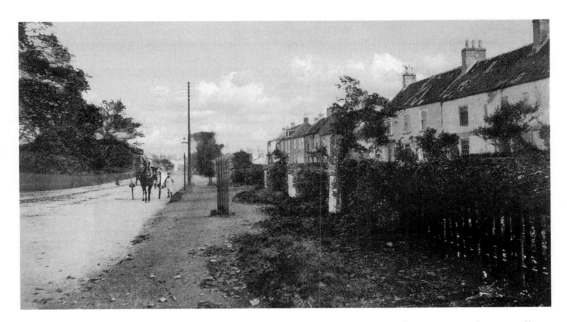

Hartburn, a small agricultural community, was formerly known as East Hartburn. A very pleasant village, it became a popular residential location for some of the wealthier inhabitants of Stockton. The tranquillity of life in the village can be seen here in this image of about 1907.

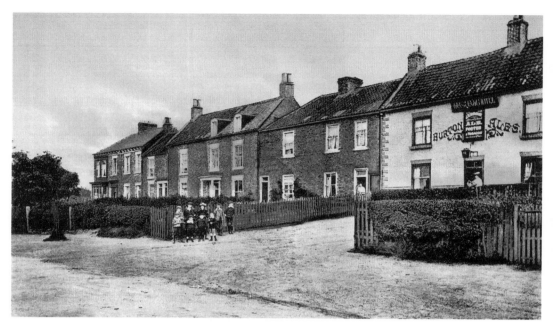

A group of children stand outside the Masham Hotel in Hartburn, *c.* 1906. The Masham Hotel was originally built in the eighteenth century but was modernised in the 1800s.

Harper Terrace, seen here in about 1907, was named after the builder. The 1857 Ordnance Survey map indicates that the line of the houses followed the line of an old Rope Walk – a reference to an earlier industry in the area.

This image from about 1908 is titled 'Manor House Terrace', although there was no manor house in the village!

The road to Darlington, which passed through Hartburn, was very much a country lane in the days before the First World War, exemplified by this image from around 1909.

The village post office is shown here mid-picture around 1909. It was part of a ribbon development located south of the road from Stockton which went through the village.

A group of children pose outside Hartburn School, *c.* 1907.

Hartburn Lodge on Harlsey Road was owned by the Raimes family before it was put up for sale in 1922. Originally built in 1903, the Lodge was a substantial house with a stable block and extensive grounds.

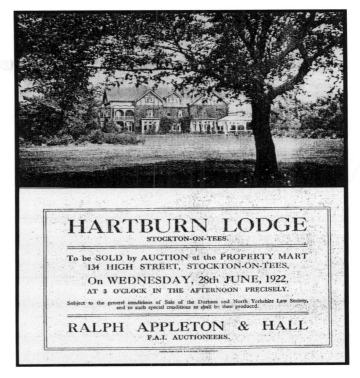

These two images of Long Newton in the 1930s show how little the area has changed. There has been some controlled modern building but this has not altered the essential nature of the village. The upper image shows the Londonderry Arms, one of two inns in the village.

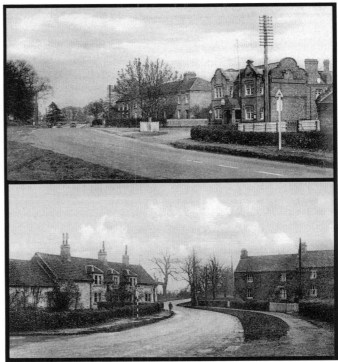

BIBLIOGRAPHY

BOOKS

Betteney, A., *Shipbuilding in Stockton and Thornaby* (Tees Valley 2003)
Graves, Revd J., *History of Cleveland* (Jollie 1808)
Harrison, J.K., *Eight Centuries of Milling in North-East Yorkshire* (North York Moors National Parks
 Authority 2008)
Heavisides, M., *A Condensed History of Stockton-on-Tees* (Heavisides, Stockton 1917)
Hempstead, C.A., *Cleveland Iron and Steel Industry* (British Steel 1979)
Horton, M., *Story of Cleveland* (Cleveland County Libraries 1979)
Menzies, P., *Cleveland in Times Past* (Countryside: Chorley, 1987)
Menzies, P., *Around Cleveland* (The History Press: Stroud 2009)
Ord, J.W., *History and Antiquities of Cleveland* (London 1846, reprinted Shotton 1982)
Richmond, T., *Local Records of Stockton and the Neighbourhood* (Stockton 1868)
Sowler, T., *History of the Town and Borough of Stockton-on-Tees* (Teesside 1972)
Tomlin, D.M., *Past Industry along the Tees* (A.A. Sotheran, 1980)
Towland, D., *Stockton's Georgian Theatre* (Stockton 1991)
Waterson, E. and Meadows, P., *Lost Houses of Durham* (Raines 1990)
Woodhouse, R., *Stockton: A Pictorial History* (Phillimore 1990)
Wordsworth, D., *Illustrated Lakeland Journals* (Diamond Books 1991)

ARTICLES IN PERIODICALS

Middlesbrough Jubilee, *Illustrated London News*, 8 October 1881
Stockton Football Club, *The Lantern Magazine*, April 1895
The Industries of Stockton, 1890

OTHER SOURCES

Ancestry website, ancestry.co.uk, Births, Marriages and Deaths Index, Census Records 1841-1901
Billingham Express, various eds from 1952-1966, available on microfiche at Middlesbrough Reference
 Library
Billingham Press, various eds from 1946-1952, available on microfiche at Middlesbrough Reference
 Library
Cleveland and Teesside Local History Society: *The Meynell Family at Yarm 1770-1813*, Heppell D.A., L.T.D.,
 Cleveland and Teesside Local History Society: History of Stockton in maps (Middlesbrough 1982)
Cleveland and Teesside Local History Society: *History of River Tees in maps* (Middlesbrough 1990)
Evening Gazette Teesside, various eds 1899-1968, available on microfiche at Middlesbrough Reference
 Library
Jeffrys Thomas, Map of North Yorkshire 1771
Ordnance Survey, 6 inch & 25 inch series, 1857, 1893, 1897, 1916
Pease Joseph, Diary Extracts, August 1828, unpublished
Smallwood Album US742, held at Teesside Archives
Stockton and Teesside Herald, various eds 1919-1940, on microfiche at Middlesbrough Reference Library
Stockton Local History Journal, *Notes on Teesside Rail Stations* (April 2006)
The Times Online Archive 1785-1985, (Times Newspapers, 2008)
The Diaries of Ralph Jackson 1749-1790 – consulted 1982-1992 at Middlesbrough Reference Library and
 other material provided by the late Adrian Ward Jackson as a result of numerous communications in
 1989
Various oral interviews conducted between 1978 and 2008, typed up as statements of individual
 memories
In addition, a large number of *Trade Directories for County Durham and North Yorkshire*, covering the period
 1828 to 1939, have been consulted and used to provide and verify information